MARGARET BOURKE-WHITE

HER PICTURES WERE HER LIFE

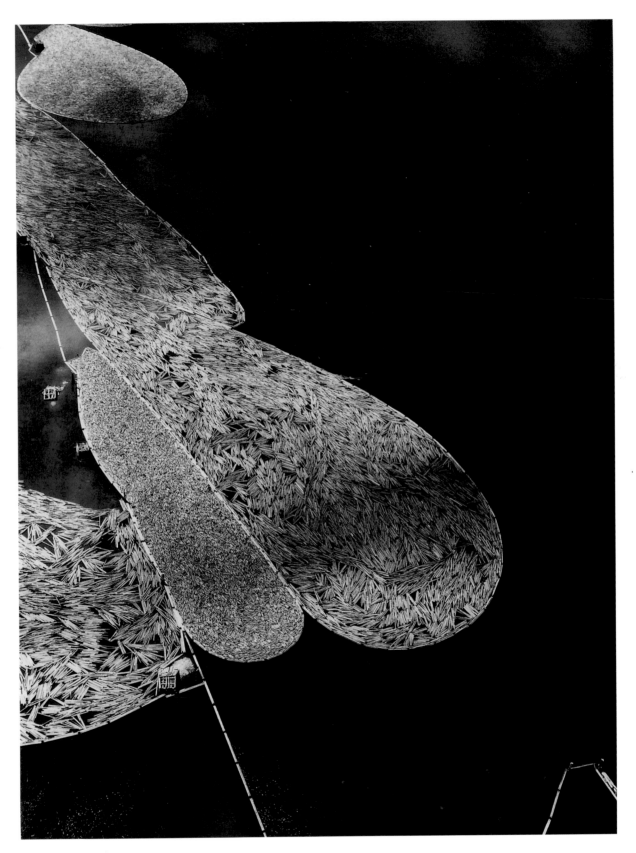

Aerial View of Log Raft, International Paper, 1937.

MARGARET BOURKE-WHITE

HER PICTURES WERE HER LIFE

Susan Goldman Rubin

Photographs by Margaret Bourke-White

HARRY N. ABRAMS, INC., PUBLISHERS

For my mother Julia B. Moldof (1906–1995)

Acknowledgments

I appreciate all the people who gave the time for interviews, in person and on the phone—members of Margaret Bourke-White's family, and friends who knew her and worked with her. In addition I wish to thank Carolyn Davis, Terrance Keenan and the staff at the Syracuse University Library, Department of Special Collections, Syracuse University, Syracuse, New York; Rick Barnes, President of the Los Angeles Chapter, American Society of Media Photographers; Todd Gustavson, Curator of Technology at the George Eastman House in Rochester, New York; Richard Hewett; Robert A. Sobieszek, Curator, Photography, Los Angeles County Museum of Art; Robert Morton; Nola Butler; and George M. Nicholson.

Project Manager: Robert Morton
Designer: Edward Miller
Photo Editor: Lauren Boucher

Library of Congress Cataloging-in-Publication Data

Rubin, Susan Goldman.
 Margaret Bourke-White ; her pictures were her life / Susan Goldman Rubin ; photographs by Margaret Bourke-White.
 p. cm.
 Includes bibliographical references and index.
 ISBN 0-8109-4381-6
 1. Bourke-White, Margaret, 1904-1971. 2. News photographers—United States—Biography. 3. Woman photographers—United States—Biography. 4. Photography, Artistic. I. Bourke-White, Margaret, 1904-1971. II. Title. III. Title: Her pictures were her life.
 TR140.B6R83 1999
 770' .92—dc21
 [B] 98-53967
 CIP

Harry N. Abrams, Inc.
100 Fifth Avenue
New York, N.Y. 10011
www.abramsbooks.com

Contents

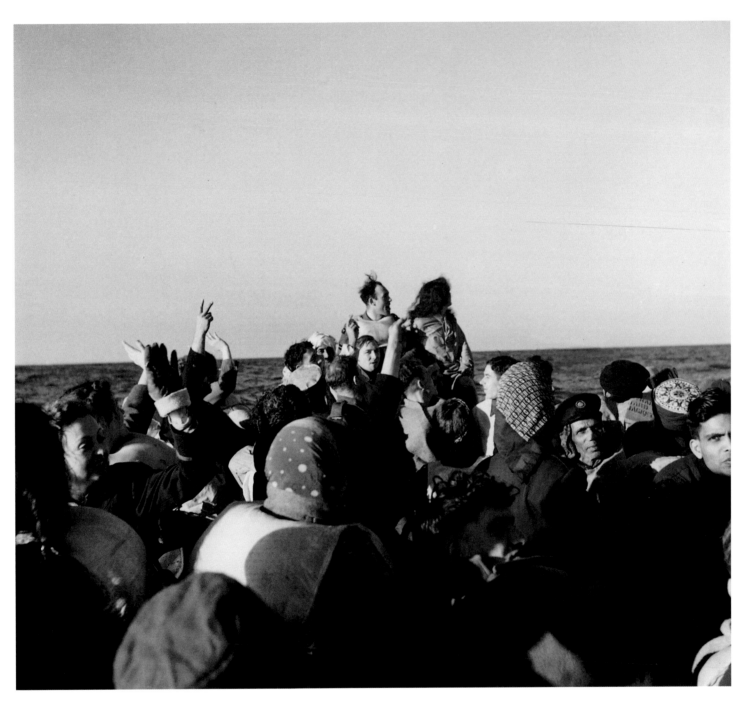

The survivors in Margaret's lifeboat joyfully wave to the British search plane.

Introduction
"I WANT TO BECOME FAMOUS"

Margaret Bourke-White hurried to her lifeboat and stood in line. For the first time in her life she was truly afraid. As her lifeboat descended to the water, swinging back and forth, she looked up and saw the ship silhouetted against the night sky. In the moonlight the ship's deck "tilted like a silver tea tray." Margaret imagined the dramatic photographs she could have taken if there had been enough light. "I suppose for all photographers, their greatest pictures are their untaken ones," she later wrote, "and I am no exception. For me the indelible untaken photograph is the picture of our sinking ship viewed from our dangling lifeboat."

The sinking ship Margaret left behind was a troopship bound for North Africa in 1942 during World War II. Margaret was covering the war for *Life* magazine, as well as for the United States Armed Services as its first woman photographer. She had been in England photographing the crews of the Flying Fortresses, the B-17 aircraft on loan from America. These squadrons had been sent to England to bomb German war factories and troops. But what Margaret longed for most of all was to go on a bombing mission herself. Male correspondents were allowed to go, but not women. A rumor spread that the Allies (America, Great Britain, France, Russia, Canada and the countries allied with them) were going to invade North Africa where German forces had overrun large areas. Margaret wanted to go, too, and take pictures. General Jimmy Doolittle, commander of the 12th Air Force, gave her permission. However, he would not let her fly to the destination. It was too risky. Instead he sent her on a troopship in a convoy along with British and American nurses, and the first five WACS (Women's Army Corps) sent overseas.

The convoy sailed into a heavy storm. Waves sixty feet high hit the ship. Sofas flew through the air, injuring passengers. Most everyone on board suffered from seasickness except Margaret. The captain ordered all passengers, sick or well, to go through daily lifeboat drills. They packed and repacked their emergency bags. Margaret stuffed hers with a Rolleiflex (a small camera), her big old telephoto lens that she had used for making portraits of world leaders, and film, leaving five other

favorite cameras behind. Then, a couple of days before they were due to reach North Africa, she heard the ship was being followed by German submarines. At 2:10 A.M. on December 22, their ship was hit by a torpedo. The impact was so great that Margaret fell out of her bunk. Quickly she and the Scottish nurses sharing her cabin yanked on their clothes, tore curlers out of their hair, slipped on their helmets, grabbed their emergency bags, and raced to the top deck. The order came to abandon ship.

Before it even reached the ocean, Margaret's lifeboat was full of water. The splash from the torpedo had flooded it. Margaret hugged her bag to her chest hoping to keep her camera dry. More water poured into the boat from the one swaying directly above. When Margaret's lifeboat hit the sea, waves pushed it back toward the ship where it would be squashed. The stewards rowing the lifeboat strained on the oars while Margaret and the other women bailed water with their helmets. Slowly they pulled away from the sinking ship. Nearby, in the dark sea, fellow passengers and crew who had jumped from or been tossed from the ship, started swimming frantically toward empty rafts that had been thrown overboard. Many people drowned. One nurse jumped from the ship's ladder into a lifeboat and crushed her back. Margaret's boat picked up a girl with a broken leg, then nine soldiers floating by on rafts. After a while in the moonlight, everyone in the lifeboats began singing, "You are my sunshine, my only sunshine." The tension and fear

were broken as everyone tried to make a bad situation better. People joked and told stories. Margaret found a pen and pad of paper in her coat pocket and made notes. Her boat drifted away from the others. "A feeling of loneliness came upon us," she later recalled.

In the early morning light, Margaret reached for her camera and took pictures. Soon she heard a hum in the sky. Overhead a British plane flew by and the survivors in the water waved. Margaret happily photographed her fellow survivors waving and laughing. A few hours later a destroyer rescued them, and that night they arrived in the North African country of Algiers. In February 1943, Margaret's pictures and text, "Women in Lifeboats," appeared in *Life*.

Because of her daring, courage, and talent Margaret Bourke-White became one of the world's best-known photojournalists, someone who tells stories with photographs. Most of her celebrated pictures came about as assignments for magazines. Her driving ambition to succeed often led her into dangerous and adventurous situations. "I want to become famous and I want to become wealthy," Margaret wrote in her diary when she was twenty-three years old. She was just starting out in photography and was determined to be independent.

At a time when most young women expected to get married, raise children, and perhaps have a hobby or spare-time occupation on the side, Margaret desired a career more than anything else. In 1927, when she began taking pictures professionally, photography was a field

Margaret Bourke-White took *Self-Portrait With Camera* (an 8 x 10 view camera) in 1933 when she was twenty-nine years old.

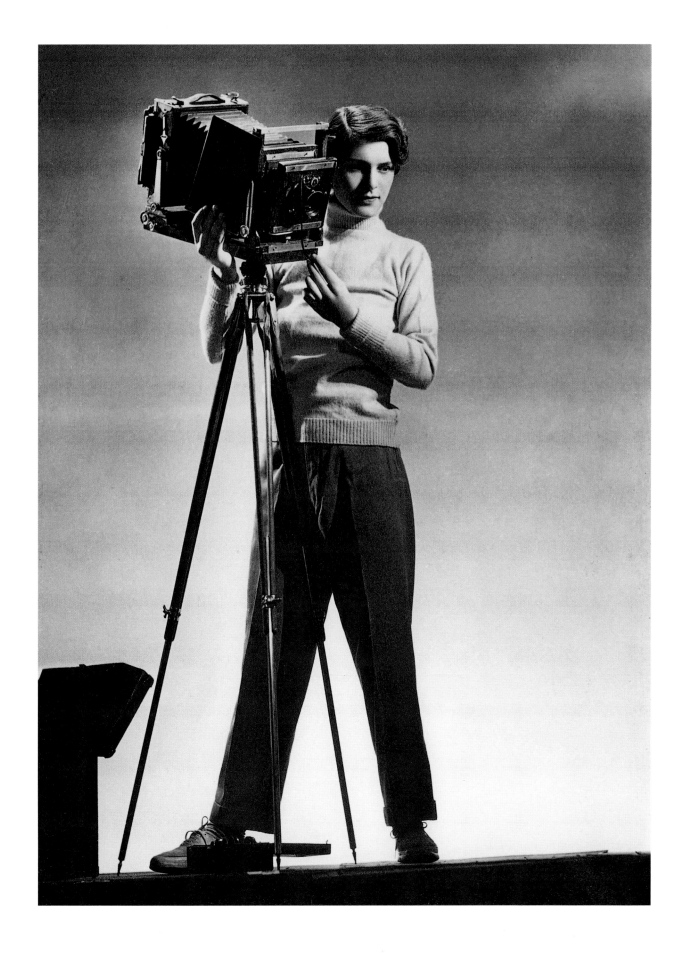

dominated by men. Of course, there were women photographers. Many of them specialized in making family portraits, or scenes of everyday life. But Margaret felt that the most remarkable pictures came from dramatic situations and important world events. She wanted to be a photojournalist. Driven by her ambition to succeed in a competitive field, she was willing to risk her life for her art.

Despite her surprising and frightening experience on the troopship in 1942, Margaret still wanted to go on a bombing mission. This time General Doolittle gave her permission to go on the bombing mission. "You've been torpedoed," he said. "You might as well go through everything."

She was taken to a secret air base in the Sahara Desert where she borrowed a fleece lined leather flying suit and cameras. The camera she had with her was not appropriate for aerial photography. So the Signal Corps loaned her a Speed Graphic, a press camera that used the large film she preferred, and a pair of K-20s. The K-20, a heavier camera, was made of metal and designed to withstand the vibrations of a plane. The men warned her, though, that the film lever of the K-20 sometimes froze in the 40-below-zero temperature she could expect flying at high altitudes. They also warned her about her hands, and told her not to take off her mittens when she worked the camera or her fingers would freeze to the metal. Last of all, they taught her how to use an oxygen mask so that she would not pass out.

On January 22, 1943, Margaret went along on a mission to destroy a German-occupied airfield outside Tunis in the African country of Tunisia. She flew in the lead plane. Four miles up in the air, she was too busy

As it heads east, Flying Fortress is photographed by Margaret.

photographing to be scared, and dragged her bulky K-20 aerial camera from window to window. "I forgot that anything existed except the need to get pictures," she wrote in her autobiography.

The mission was highly successful but as they were leaving, German fighter planes attacked them. Although Margaret's plane was hit, they safely returned to the base. "Life's Bourke-White Goes Bombing" was printed as the lead article in Feburary, 1943. The editors included a picture of her in a flying suit. It became her favorite portrait of herself.

Margaret in her high-altitude flying suit, 1943 (photographer unknown)

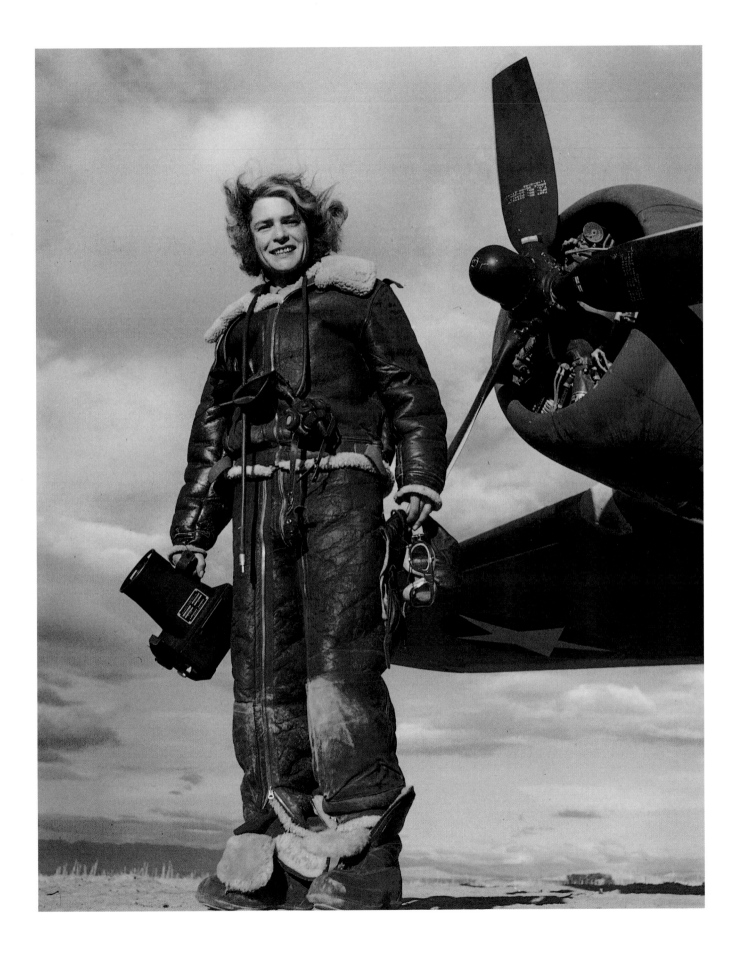

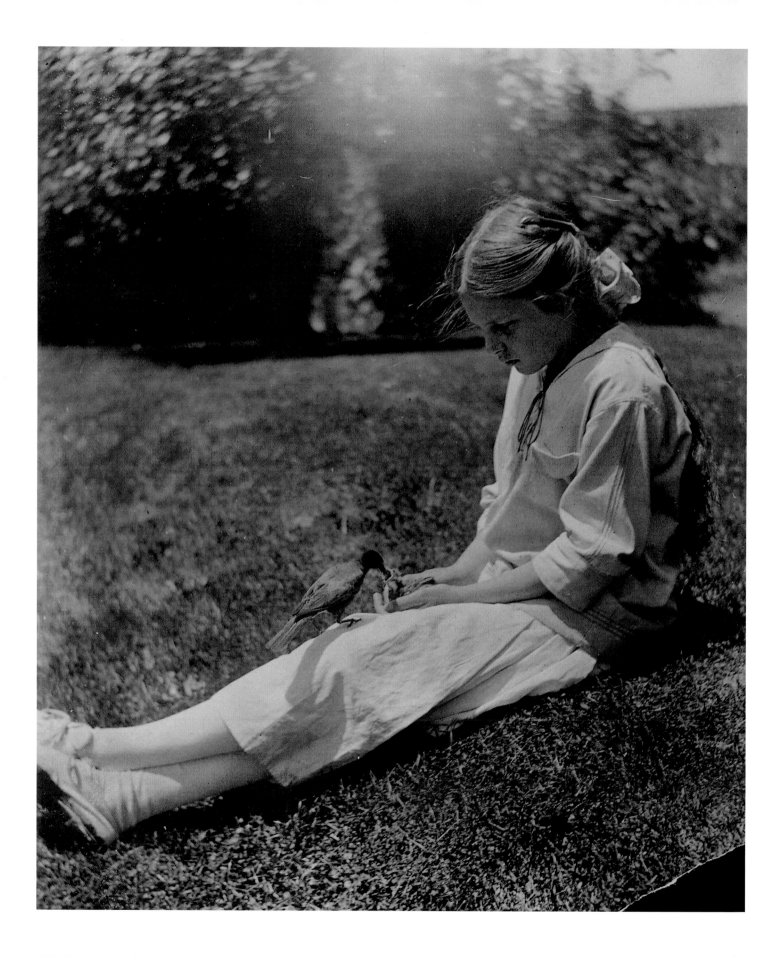

Chapter One
THE LOVE OF TRUTH

Margaret Bourke-White came from a family that valued hard work and achievement. Her father, Joseph White, was an engineer and inventor who worked in a New Jersey factory that manufactured printing presses. Over the years Joseph designed many improvements such as the first Braille press that printed books that blind people could read by touch. "My father was very artistic," Margaret said in an interview, "and knew what was the best in everything, and I simply adored him." Joseph was born into an Orthodox Jewish family, but he was not a religious man. He became involved in the Ethical Culture movement. It was based on a belief in rational thought rather than on faith in a single deity.

Margaret's mother, Minnie Bourke, came from an Irish-Catholic family in New York. When Minnie was a young woman, she was as spirited and strong-willed as her daughter Margaret was to become. Minnie took up bicycling, considered a sport for men only at the turn of the century. Joseph courted Minnie by going on long bicycle rides with her into the country. Since they both prized education and self-improvement, he brought along philosophy books in case they ran out of conversation. On June 14, 1898, they were married and vowed to create "a perfect mental and moral home."

Their first child, Ruth, was born in 1901, and Margaret was born on their sixth wedding anniversary, June 14, 1904. Their third child, Roger, was born seven years later. Raised as Christians, the children hardly ever saw their Jewish relatives. When their Jewish grandmother occasionally came for a visit, Minnie would not speak to her. According to other members of the family, Minnie was anti-Semitic and didn't like her in-laws, and she passed these attitudes on to her children. In fact, they didn't know they were half-Jewish until they were much older. The secret of Margaret's heritage troubled her as a young adult.

Margaret at age eleven took care of a baby robin that had fallen from its nest. The father robin learned to trust her and would fly right into her lap to feed the young bird (photographer unknown).

Even though Minnie and Joseph came from different cultural backgrounds, they were both perfectionists and set high standards for their children. Chewing gum, slang, card games, and comic books (or "funnies") were forbidden because they were considered a waste of time. Margaret, Ruth, and Roger were not even allowed to visit friends who had comic books in their houses. Margaret thought her mother was too strict but later praised her as "a born teacher." Minnie put up maps on the walls of the house, which may have sparked her daughter's love of travel.

When Margaret was about four, the family moved from the Bronx where she was born to the town of Bound Brook, New Jersey. In the daytime, Margaret began running away to explore. Finally Minnie started dressing her in a bright red sweater with a sign sewed on the back: "My name is Margaret Bourke White. I live at 210 North Mountain Avenue. Please bring me home."

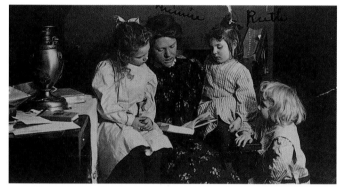

From her father, Margaret learned self-confidence. His motto was: You Can. Joseph was so busy thinking about his work, inventing improvements for printing presses, that he often became silent for long periods of time. Sometimes he would forget to finish a meal and run off to scribble down his ideas. In later years Margaret gave him credit for handing down his work ethic to her. "Perhaps this unspoken creed was the most valuable inheritance a child could receive from her father. That, and the love of truth, which is requisite No. 1 for a photographer."

Joseph introduced Margaret to the exciting world of machines. One day when she was eight, he took her to the factory where the presses were being built, and she saw a foundry for the first time. At the foundry, workers melted metal and poured it into molds. Margaret thrilled at the sight of the flowing metal and flying sparks. "I can hardly describe my joy," she wrote in her autobiography. "To me at that age, a foundry represented the beginning and end of all beauty. Later when I became a

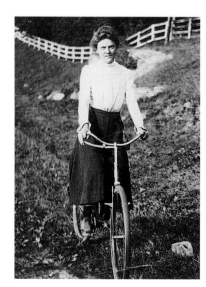

Top: Joseph White, Margaret's father, at age twenty-nine (photographer unknown).

Middle: In this family photograph, Minnie reads to her children (photographer unknown).

Bottom: Minnie Bourke, Margaret's mother, on a bicycle (photographer unknown).

photographer, with that instinctive desire that photographers have to show their world to others, this memory was so vivid and so alive that it shaped the whole course of my career." Industry was to become her first important subject as an artist.

Although her father was interested in photography, Margaret claimed that she did not take any pictures during her childhood. When the family went on trips, Joseph brought along his camera and asked Margaret to take notes about what he photographed. Usually his favorite subjects were his family, flowers, and birds.

Margaret shared her father's interest in nature. One time she collected two hundred caterpillars and kept them in upturned glass jars on the living room window sill. Her father taught her how to feed them properly and take care of them. She patiently waited for them to turn into butterflies. "When a chrysalis began to wriggle and show signs of life," Margaret recalled, the whole family "often sat up all night in the hope of seeing the butterfly emerge with crumpled wings and gradually spread them before our eyes until it was a full grown creature."

On long walks in the woods, Margaret's father pointed out snakes and showed her which ones were harmless and how to pick them up. Margaret brought garter snakes home and kept them as pets in addition to her rabbits, hamsters, and turtles. She decided to become a biologist when she grew up. "I was very anxious to go to the jungle and do all the things women never did before," she wrote, "so I specialized in herpetology and studied reptiles hoping that sometime I would be good enough to be sent on an expedition."

Once she took a harmless puff adder snake to school. The other children thought it was poisonous and were frightened, and the principal made her take it home. Margaret found other ways to get attention. At Plainfield High School she joined the debating club and became president of the dramatic club. She also was an editor of the high school newspaper and the yearbook. Margaret's classmates thought she might become a writer. She still expected to seek fame as a scientist. But when Margaret went to college, her career goals took another direction.

Margaret at age seventeen or eighteen poses with a pet snake (photographer unknown).

Chapter Two

"I WILL BE A SUCCESS"

When she was seventeen, Margaret entered Columbia University in New York City. She still intended to become a herpetologist, someone who studies the behavior of amphibians (frogs and salamanders) and reptiles (snakes, lizards, and crocodiles). She worked hard at her classes. Then in January, her father suffered a massive stroke. A blood vessel leading to his brain hemorrhaged, causing paralysis on the right side of his body, then both sides. He lost consciousness, slipped into a coma and died. Margaret was devastated. She adored her father and identified with him. But driven by her goal to succeed, she carried on with her life and immediately dealt with practical problems.

Since her father had not left much money, Margaret had to find a way to pay her tuition and continue her education. Her Uncle Lazar White, her father's brother and also a well-known engineer, offered to help her. In meeting him and talking to him about the family background, Margaret made a startling discovery. Although she had been raised as a Christian, she now found out that her father was Jewish. The news came as a shock. At that time, in the 1920s, there was a strong wave of anti-Semitism in the United States. There were quotas or limits to the number of Jews allowed in schools and businesses, and it was difficult for Jews to enter certain fields. Perhaps because of her desire to succeed, Margaret concealed her Jewish heritage, and she kept it a secret throughout her life.

When she returned to Columbia, she signed up for her first photography class. She wrote in her notes, "I think my great love for my father and the fact that he was

This early architectural photograph, a campus scene at Columbia University, shows Margaret's attention to composition. The subject, seen from a distance, is softened by a leafy diagonal branch in the foreground.

so much interested in photography was a strong added incentive when I began work at the Clarence H. White School."

Clarence White (no relation to Margaret) had taught at Columbia, and then had opened his own school in his home. He was a member of the group known as the Photo-Secession. It had been founded by photographer Alfred Stieglitz and included such great photographers as Edward Steichen. The group aimed to prove that photography was an art, but in doing so, they tried to make their pictures look like paintings. They smeared Vaseline on the lenses of their cameras and added scratches to their negatives in the darkroom. Margaret learned that "to be artistic a picture must be blurry." This kind of photography was called Pictorialism.

At that time there was no color film, only black and white. So, to make their pictures vivid and well designed, students learned how to use contrast. They balanced light against dark, positive shapes against negative space. White taught the students how to carefully frame or compose their pictures. In her notes Margaret wrote, "You somehow absorbed from him the feeling that any picture that was important enough to make was one that the photographer should work on until he had made it as perfect as he could possibly make it."

White trained many photographers who were to become famous in the 1920s and 30s—Dorothea Lange, Laura Gilpin, and Ralph Steiner. Margaret became friends with Ralph Steiner, and their friendship lasted long after they left school.

While studying with White, Margaret decided to be a photographer who would go along on safaris and take pictures of animals. She loved reptiles and would sometimes walk into Clarence White's house with two snakes wrapped around her arms.

Margaret's mother bought her her first camera, a secondhand $3\frac{1}{4}$ x $4\frac{1}{4}$ Ica Reflex with a cracked lens. But the crack came in handy making Margaret's pictures look scratchy and painterly when she was still working in the Pictorialist style. The crack softened or diffused the light, and created fuzzy edges. Margaret took her first pictures on old-fashioned glass plates rather than film. When she looked through the lens, she saw a reversed image projected onto a viewing glass mounted in back of the camera. (Everything to the left was on the right, and everything to the right was on the left.) So she had to acquire the ability to correctly tell what her composition would look like.

Although Clarence White's approach to photography was poetic, he encouraged his students (especially females) to use their cameras for commercial projects. White knew that women had a harder time getting work as photographers. Yet he felt that women as well as men could bring an artistic eye to money-making jobs. He even hired a woman to teach advertising photography, a field dominated by men in those days.

By the summer of 1922, Margaret was good enough to take a job as the photography counselor at a camp in Connecticut. She also ran a little business on the side. She made picture postcards of the camp and portraits of the

Margaret poses on the steps of the University of Michigan library, 1924 (photographer unknown).

campers, and sold them as souvenirs to the kids to send home to their parents. By summer's end she still did not have enough money to pay for her second year of college. Her Uncle Lazar was now helping her brother Roger go to private school.

Then miraculously, some generous neighbors at home in Bound Brook offered to pay her tuition. With her pet snake, Margaret headed for the University of Michigan at Ann Arbor to study with Alexander G. Ruthven, a leading zoologist. Dr. Ruthven's specialty was herpetology, and he directed expeditions to Colombia, Vera Cruz, and British Guiana to collect snakes for the Museum of Zoology at the University of Michigan. These were just the kinds of expeditions of which Margaret had dreamed. After a few weeks, however, Dr. Ruthven and Margaret agreed that although she was a serious student, she would never be a successful herpetologist. (It is not known exactly why.) When he asked her what else she wanted to do, she replied, "I should like to be a news photographer-reporter and a good one." She also said she wanted to write nature stories for children and illustrate them with her own photographs. Dr. Ruthven encouraged her to pursue that goal and asked her to take pictures for the museum and for an article he was writing. In her diary Margaret wrote, "Dr. Ruthven is helping me on one condition, that I make a 'world figure' of myself. Everybody expects so much of me—I will be a success."

That winter, when Margaret was eighteen, she met a young man named Everett "Chappie" Chapman in a revolving door at the campus cafeteria. She was on her

Everett "Chappie" Chapman sits on the steps of the University of Michigan library, 1924.

way into the cafeteria, and he was on his way out. Chappie kept the door turning with Margaret in it until she agreed to go on a date with him, and they fell in love.

Chappie was six feet tall, handsome, and a senior majoring in electrical engineering. He liked photography, too, and knew more about its technical aspect than she did. Soon they were taking photographs together and printing them side by side in the darkroom.

In May Chappie asked Margaret to become engaged. She did not feel ready to be tied down, and was deter-

mined to complete her college education. Chappie offered to wait. But Margaret felt troubled and uncertain about what to do with her life. In the fall, she began seeing a psychiatrist. She talked about Chappie and decided to marry him in three years' time. But something else was bothering her. She finally revealed to the doctor the secret about her Jewish roots, and admitted that she felt like an outsider because of it. Despite her outward air of confidence, she had what the psychiatrist called an inferiority complex. As soon as Margaret had told someone else the truth about her background, she felt relieved and more at peace with herself. However, it would take many years for her to accept and understand the Jewish side of her heritage, and she never mentioned it in her autobiography or to her closest friends.

The day following her session with the psychiatrist, she and Chappie became engaged to be married sooner than the three-year time limit they had set. They chose as their wedding day, Friday, June 13, 1924, the day before Margaret's twentieth birthday, just for the fun of it. They purposely picked a day that most couples would avoid because it might bring bad luck. And the marriage did get off to a poor start. Chappie's mother sobbed miserably throughout the ceremony. Then she showed up (uninvited) at the cottage where Margaret and Chappie had gone for their honeymoon. One day when Chappie was away from the cottage, his mother angrily blurted out to Margaret, "I've lost a son. You got him away from me. I never want to see you again." Margaret was so hurt and stunned that she rushed out of the cottage and went to stay with friends. Chappie never

stood up to his mother. He felt torn between loyalty to her and love for Margaret.

Despite the obstacle of Chappie's mother, Margaret tried to make her marriage a success. In the fall she and Chappie moved to Purdue University in Indiana where he landed a teaching job. Margaret took courses there in paleontology, the study of fossils. She and her husband were not happy, though. He was moody and withdrew into long silences just like Margaret's father. She started to dream about an independent life centered on her work. Women had just won the right to vote in 1920, and Margaret sensed that this was an opportune time for her to launch a career. However, it would be difficult for her to become a photojournalist while staying married to Chappie, especially as her mother-in-law continued to interfere with their life.

When Margaret and Chappie moved to Cleveland, she taught classes for children at the Cleveland Museum of Natural History and went to night school at Case Western Reserve University. By fall 1926, despite her efforts, she knew the marriage was over and she gathered the strength to move away.

"It was as though everything that could really be hard in my life had been packed into those two short years," she wrote, "and nothing would ever seem so hard again." Margaret said of her difficult mother-in-law: "I am grateful to her because, all unknowing, she opened the door to a more spacious life than I could ever have dreamed."

Chapter Three

ON A RED-GLOVE DAY

Margaret decided to go to Cornell University in Ithaca, New York, for her senior year. It was her fifth school! But she was determined to finish college and get her diploma. "I chose Cornell not for its excellent zoology courses," she wrote, "but because I read there were waterfalls on the campus."

Margaret needed money so she took a job working at the front desk of her dorm. She also waited on tables at the college dining hall three hours a day in exchange for meals. But she soon was able to give up both jobs. "It was the drama of the waterfalls that first gave me the idea I should put that old cracked lens to work," she wrote. That fall Margaret took lovely, unusual pictures of buildings on campus: Baker Dormitory seen from a distance on a snowy day, the crescent-shaped football stadium beneath a vast, cloudy sky. She used the soft-focus, misty style she had learned from Clarence White, and the strong sense of composition he had taught her. The *Cornell Alumni News* bought her photographs and when the dean of the architecture school saw them, he asked Margaret to take pictures of his home. He was so pleased with the results that he gave her letters of recommendation. Graduate architects also saw her pictures, and wrote to her praising her dreamy images of campus buildings that brought back fond memories. They suggested she become an architectural photographer.

Margaret still didn't think she knew that much about photography. After studying biology for so many years, she had applied for a job as Curator of Herpetology at the American Museum of Natural History in New York and thought she would get it. (A Curator of Herpetology looks after a collection of amphibians and reptiles, and

conducts research.) Yet she realized she could actually be a professional photographer. "What a tantalizing possibility," she wrote. "I was surprised at the growing feeling of rightness I had with a camera in my hands."

Margaret felt that she needed an objective opinion of her ability from an architect not connected with Cornell. Someone gave her the name of an architectural firm in New York City and she went there during spring vacation. The head of the firm looked at her portfolio and was greatly impressed.

"After the kind of golden hour one remembers for a lifetime," Margaret wrote, "I left with the assurance that I could 'walk into any architect's office in the country with that portfolio and get work.'"

Back at Cornell she finally earned her diploma after six years of college studies. Chappie came to visit her, and though they tried to patch up their marriage, it was impossible. So in 1927, Margaret left Ithaca and moved to Cleveland where her mother and brother now lived. A year later she divorced Chappie and changed her name back to White. Her middle name had been Bourke, her mother's maiden name. Margaret added a hyphen and became Bourke-White to make herself sound more distinguished.

In Cleveland Margaret opened a studio in her little apartment, developing the film in the kitchen sink. She did this at night because she could not totally seal off the room to any outside light. In complete darkness, doing everything by touch, she placed her film in a liquid film developer to bring up the image. After several minutes she put the film into a stop bath to stop the developing process, then a fixer to make the image permanent. Now she could turn on the light and see the negative. The image appeared in reverse: Everything black was white, and everything white was black. Margaret washed off the film and hung it up to dry. When the film was dry she selected the negatives she wanted to print. By the light of a dim red bulb, she placed the first negative in the enlarger to project the image onto light-sensitive paper. Then she took the paper and placed it in a tray of liquid paper developer.

Now for the first time, she was going to see what she had captured. Like magic, the image gradually appeared. This was the most thrilling moment! Margaret, with her artist's eye, knew when it was time to lift the print out of the developer and put it into a stop bath, then fixer (so that it wouldn't fade). But she still had several hours of work ahead of her for she had to wash and dry the print.

In searching for images to photograph, Margaret walked around the city and discovered a part of town along Lake Erie known as the Flats. The Flats was an industrial district—factories and foundries—criss-crossed by railroad tracks and edged with steel mills. Smoke stacks rose along the horizon. To Margaret the Flats was "a photographic paradise." The forms excited her. But her dream was to get inside the steel mills and make "experimental industrial photographs."

Meanwhile, she had to support herself and pay for supplies. She looked for commissions from architects and landscape architects who were Cornell graduates. Margaret knew she needed every advantage to get work and thought looking attractive would help. She had

only one grey suit and dressed it up with either red or blue accessories. Not only did she keep notes on her prospective clients, but she also jotted down which hat and gloves she had worn, the red or the blue. On a red-glove day she got her first job—photographing a school. Editors of a national architecture magazine promised to feature the pictures if they were publishable. Other photographers had tried but failed.

Margaret knew why when she arrived at the site. The school stood in a muddy lot littered with junk. She decided to shoot the building in silhouette against the sunset. However, the sun set on the wrong side of the school. Next, she planned to take the pictures at sunrise. But for days the sky was overcast at dawn.

Then Margaret had another idea. She rushed to a florist, bought an armful of asters, stuck them in the ground, and placing her camera low, shot over the tops of the flowers. As she moved around the building for different views, she took the flowers with her and replanted them, creating her own landscaping. Margaret solved the problem, even though it meant bending the truth. When she delivered the pictures, her clients were "amazed at the miraculous appearance of landscaping." Perhaps it gave them an idea of what they could do to beautify the site. The pictures were published and more assignments followed.

Other architects hired Margaret to photograph the grand houses and estates they had built for their rich clients. One day while she was making her rounds with her portfolio, she passed through a public square and saw a preacher standing on a soapbox delivering a sermon. No one was listening except a flock of pigeons at his feet. "What a wonderful picture!" she thought.

Margaret did not have a camera with her, so she dashed into the nearest camera store and borrowed a Graflex from the clerk, Alfred Hall Bemis. (The Graflex was a large, heavy 4 x 5 camera, the kind used by news photographers.) On her way back to the square she bought some peanuts and asked onlookers to toss the nuts into the air so that the pigeons would flutter at the preacher's feet. She humorously called her picture, *A Preacher and his Parishioners* and sold it to the Chamber of Commerce for their magazine, *The Clevelander.* They used it on the cover—it was her first, but many more covers were to follow.

Mr. Bemis, or Beme, as she called him, became her friend and technical advisor. He built an enlarger for her. The enlarger was a machine with a light bulb on top of a bellows and lens, with the photographic paper on the bottom. It worked like a slide projector: the farther away the enlarger head was from the paper, the bigger the image appeared. It enabled Margaret to print small negative images onto the photographic paper and enlarge them to any size she needed. Beme recognized her talent and gave her moral support. "Listen, child," he would say, "you can make a million technicians but not photographers, and that's the truth."

In the Flats, Margaret started taking pictures of trains, bridges, smokestacks, and factories. She was fascinated by the Terminal Tower, a new skyscraper being built. "I

A Preacher and His Parishioners, Cleveland, 1928

24

always loved things that were under construction better than things that were finished," she said. She photographed the Terminal Tower from different angles and in different styles. Now she was using a proper view camera mounted on a tripod. (When she looked through the lens she saw an upside-down image so she had to acquire the ability to tell what her composition would look like right-side up.) Some of the pictures were soft and painterly, still in the style of Clarence White and the Pictorialists, others were in sharper focus with powerful patterns of dark and light. Some were taken at daybreak, others at night. Margaret didn't think about selling these pictures. They were her art. Other American artists—painters and photographers—such as Charles Sheeler, Paul Strand, and Charles Demuth, were also excited about industry and machinery as subject matter. The 1920s marked the beginning of a period called the Machine Age. In November 1927, Margaret sold her first industrial photograph to a bank, the Union Trust Company. The picture, *High Level Bridge*, shows a detail in silhouette. The composition of white spaces against black shapes is so powerful it looks abstract. The picture was published on the cover of *Trade Winds*, the bank's monthly magazine. Every month after that, for the next five years, *Trade Winds* bought a cover photograph from her.

Now that she had some money, Margaret bought a used car, which she named Patrick. She also made herself a new purple dress to vary her outfits. She hemmed up three velvet camera cloths—purple for her purple dress, blue for her blue outfit, and black for her red. The

Margaret, dressed in stylish clothes, shows off her first car, 1928 (photographer unknown).

camera cloths went over her head when she was taking pictures with her view camera during the day. The cloths shut out light and made it easier for her to see an image through her lens. When her old friend from the Clarence White School, Ralph Steiner, came to town he teased her about coordinated colored cloths.

He also urged her to give up soft-focus pictures and take realistic ones in the new style called Straight Photography. The camera was a machine, he argued, that was meant to take photographs that looked like photographs. Margaret changed her approach. Her images became crisp and sharp. Deep blacks and brilliant whites replaced soft shades of grey.

By the end of 1927, the owners of the Terminal Tower hired her as their official photographer, and in

High Level Bridge, Cleveland, 1929

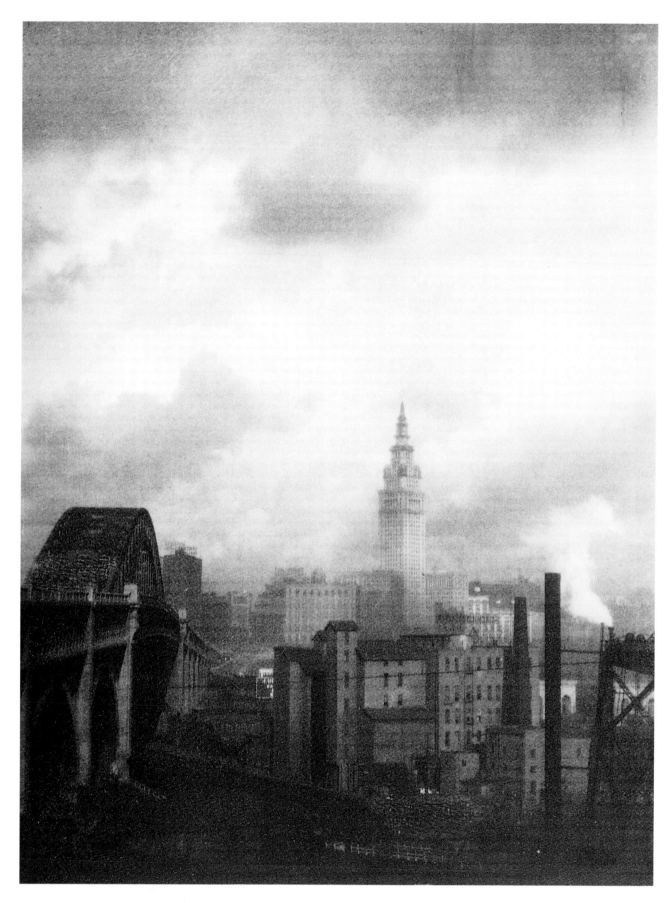

28

*Terminal Tower,
Cleveland, 1928.*
This painterly
photograph is
in soft focus.

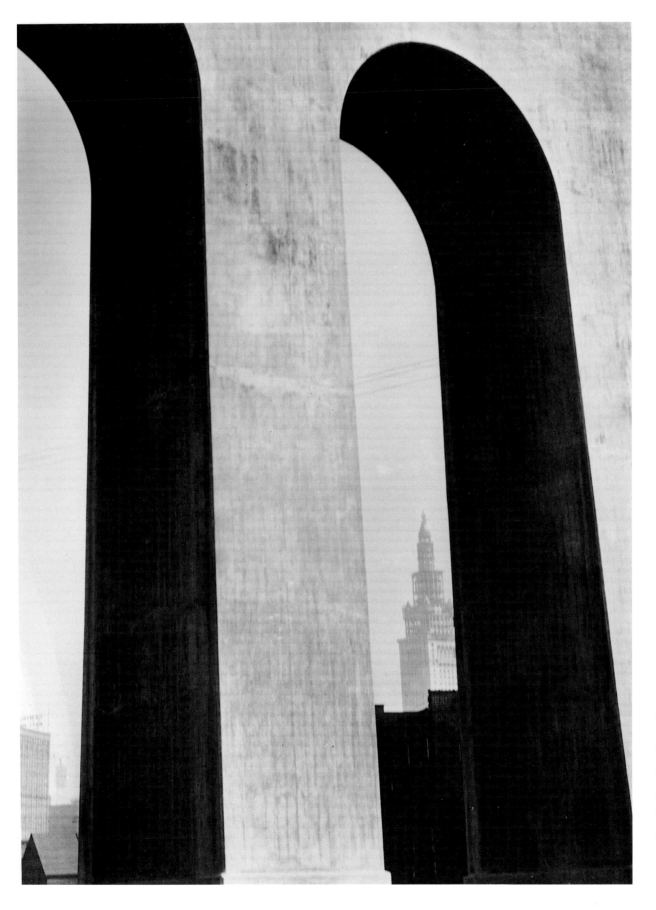

Terminal Tower, Cleveland, 1928. This image of the Terminal Tower, as viewed through the arches of a railroad viaduct, is in sharp focus.

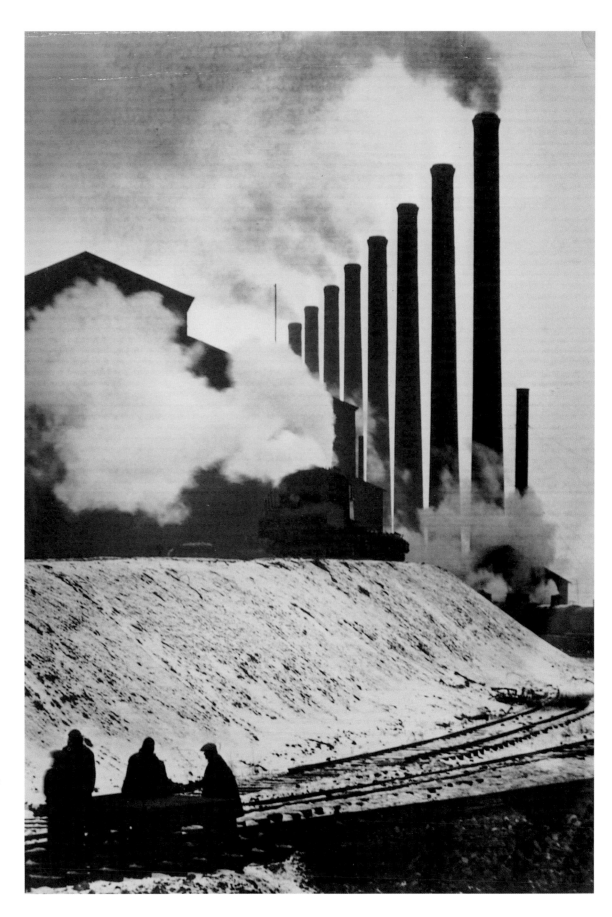

The towering
smokestacks
of the Otis
Steel Company
in the Flats,
Cleveland,
1927–28

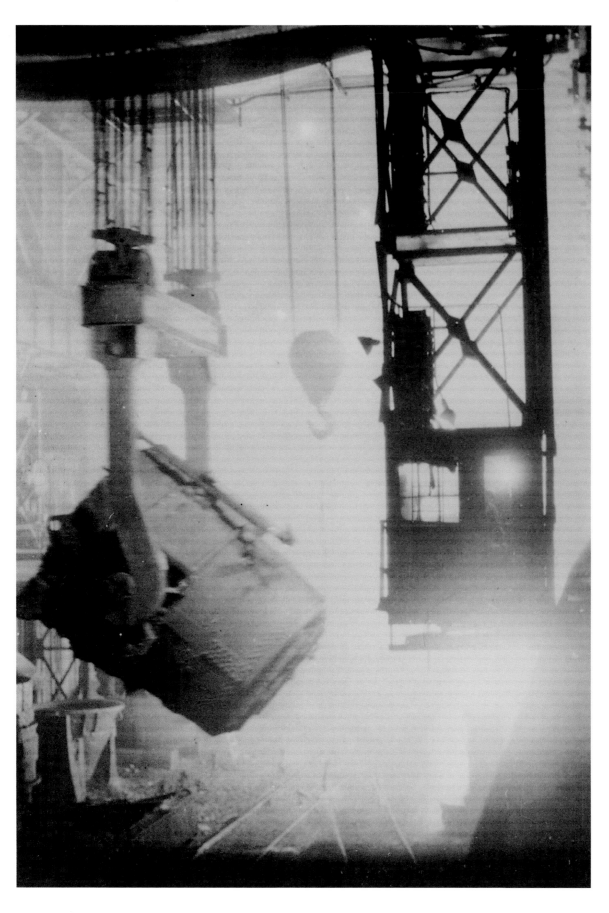

200-ton Ladle,
Otis Steel Company,
1929

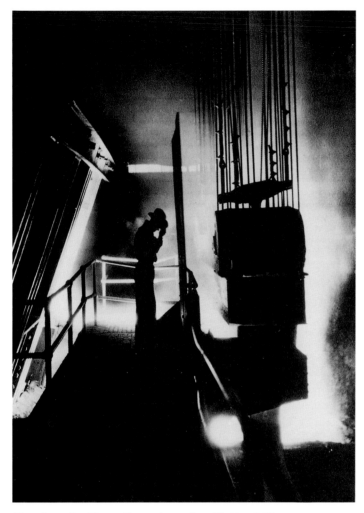

Pouring the Heat. Open hearth mill, Ford Motor Company, Detroit, 1929. A Ford Motor company foreman is silhouetted against the glare of an open-hearth mill.

March of the following year she rented a studio on the twelfth floor of the building. Now she had enough money for the special lens she needed to photograph "the enchanted steel mills" of the Flats. But how was she going to get inside "that magic place"?

Her chance came when she arranged to meet Elroy

Kulas, head of Otis Steel. Kulas did not understand why she wanted to take pictures of a steel furnace. Margaret explained that it was "a magnificent subject for photography," and that she wanted to "capture the spirit of steelmaking in photographs."

Kulas said the last woman who had been in the steel mill had fainted. Margaret assured him that she was not the fainting kind. He warned her about the dangers—acid fumes, overpowering heat, hot metal. Finally, he agreed to let her take pictures while he was in Europe for a few months. They agreed that when he returned and saw how the pictures came out, he could decide whether to buy any.

The first night Margaret went to the steel mill to begin choosing viewpoints, she was "dancing on the very edge of the fiery crater, taking pictures like blazes and singing for joy," remembered her friend Beme who went with her.

However, she faced enormous technical problems. Her first pictures were underexposed and appeared as meaningless streaks of light. Beme, and his assistant, Earl Leiter, a photofinisher who did printing and retouching, brought in floodlights, flash powder, and a faster lens. Nothing worked, but Margaret did not give up.

Next, she tried closer viewpoints, but the intense heat of the molten steel blistered the varnish on her camera and made her face red, as though she had been sunburned. Margaret climbed up the hanging ladder into the overhead crane so she could shoot directly into the molten steel when it was poured. But the crane cab started shaking, and her pictures were blurred.

The situation seemed hopeless until a traveling salesman stopped in Cleveland on his way to Hollywood. The salesman, a friend of Beme's, had samples of a new kind of light for shooting movies, magnesium flares. He went to the steel mill with Margaret and they set off the flares (like the kind used today to warn drivers of an auto accident on the road). When she developed the negatives she finally had what she wanted: a clear, sharp image of liquid metal poured from a 200-ton ladle. She had even recorded the actual path of the sparks from the furnace.

When she printed enlargements, though, the pictures were dull and lifeless because the paper lacked richness. Another salesman, who was also a friend of Beme's, passed through Cleveland with samples of a unique Belgian paper. He gave some to Margaret. Now that she had a better quality of paper, one that produced deeper blacks, brighter whites, and a greater range of grays, she finally created prints that expressed the excitement and drama of steel production.

By this time, Elroy Kulas, head of Otis Steel, had returned from his trip. Margaret showed him twelve of her best shots. Kulas bought eight of them, which he later printed in a book entitled *The Story of Steel* for his stockholders.

Many of the images were reproduced in newspapers and magazines. In May 1928, Margaret's photograph of the steel mill's 200-ton ladle won first prize in "photography, landscape" at the Cleveland Museum of Art's annual exhibit of work done by Cleveland artists and craftsmen. The show, held every May, featured oil painting, watercolors, and photographs, as well as jewelry and glassware. For this exhibit Margaret titled her prize-winning picture, "Romance of Steel." A newspaper headline read, "GIRL'S PHOTOGRAPHS OF STEEL MANUFACTURE HAILED AS NEW ART."

Some critics did not believe that a woman had taken the pictures, and rumors spread that Margaret was fronting for a male photographer. But she eventually squelched the rumors, and by 1929 another headline read, "DIZZY HEIGHTS HAVE NO TERRORS FOR THIS GIRL PHOTOGRAPHER WHO BRAVES NUMEROUS PERILS TO FILM THE BEAUTY OF IRON AND STEEL."

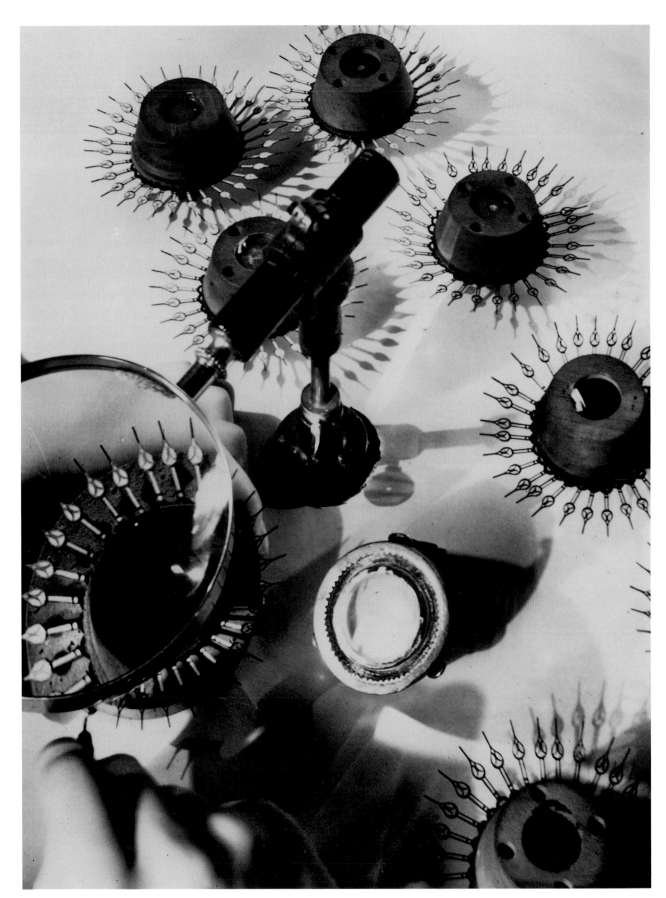

Watch Hands,
Elgin Watch,
1930

Chapter Four
SEEKING A WIDER WORLD

In May, 1929, Margaret received a cable from Henry Luce, publisher of *Time*, the weekly news magazine. Luce had seen her Otis Steel photographs in a newspaper and wanted her to come to New York right away at his expense.

As soon as Margaret walked into Luce's office, he told her about a new magazine he was starting. The publication would focus on business and industry and feature dramatic photographs. Pictures and words would work together. Margaret was thrilled. "This was the very role I believed photography should play," she wrote, "but on a wider stage than I could have imagined."

Luce introduced her to Parker Lloyd-Smith, who was to be the managing editor of the as yet unnamed magazine. They asked her if they could use her steel pictures in the dummy, a preliminary layout, that would be shown to prospective advertisers. Margaret said yes and agreed to be on the staff. But she only wanted to work on the magazine six months of the year. She needed the other six for her own projects. Luce consented to her terms, and they planned to start work that summer.

Excitedly Margaret sent a letter to her mother who was teaching at a school for the blind. "I feel as if the world has been opened up and I hold all the keys," Margaret wrote. On the fourth of July, she began accumulating an inventory of stories for the new magazine, named *Fortune*. Not only was she the first photographer hired, she was the *only* staff photographer for the first year. Sometimes writers accompanied her on assignments to do their research while she took pictures. Archibald MacLeish, the poet, went with her to the Elgin Watch factory. They were "both enchanted by the exquisite shapes of minute watch parts." Margaret's picture, *Watch Hands*, is considered one of her most beautiful. At first glance, the close-up view of the tiny watch parts seems to be a picture of sunflowers. Then, upon looking more closely, the viewer sees the hand of the craftsman applying luminous paint to the tiny watch hands as he looks

through his magnifying glass. Margaret photographed this subject from above. She carefully planned the lighting to create soft shadows for contrast. The resulting picture did more than communicate information about the watch industry, it was art.

One of her best-known pieces for *Fortune* was the lead story for the first issue. Much thought went into choosing the subject. It had to be "an eye-stopper—an industry where no one would dream of finding 'art.'" The final choice? Hogs.

Margaret and Parker Lloyd-Smith went to Chicago

Hogs Hanging, 1930

and spent a week at the Swift meat-packing plant. Margaret photographed the meat-packing process "from live hog to dressed carcass." Her piece made an important contribution to the history of photojournalism, for it was the first photo-essay. Rather than using one picture, she used many to tell her story visually. She arranged her pictures in sequence with a beginning, middle, and end. In those days, before television, pictures brought information to the public in a new way. People did not trust the written word alone. They wanted to see things for themselves.

Margaret's opening picture showed the hogs arriving at the plant. The next photographs showed carcasses hanging in rows, then meat cutters trimming bacon, and packaging meat, and finally, a huge mound of pig dust, ground from the remains and later made into feed for livestock. The motto of the Swift Company was, "We use all of the pig but the squeal."

The smell of the pig dust was so awful that Parker Lloyd-Smith ran to sit in his car and rolled up the window. But Margaret stayed to take her pictures. She was relentless in her quest for perfection; she spent two hours in the stinking place, getting the man who shoveled pig dust to hold his pose for fifteen minutes at a time. Afterward, she left her camera cloth and light cords behind to be burned because there was no way to get rid of the foul odor.

Her photo-essay received rave reviews. The *New York Times* described it as "lyric." One reporter said, "If the magazine ever had a trademark, it was Bourke-White."

The first issue of *Fortune* came out in February 1930, shortly after the stock market crash of October 1929. Many people thought the magazine would close because the country was now in the throes of the Great Depression. Instead, *Fortune* became a huge success.

Margaret's many assignments kept her on the move. A story about the International Paper Company took her to Canada. For another, on coal mining, she went to Pennsylvania. And in New Jersey she photographed the Campbell Soup Company.

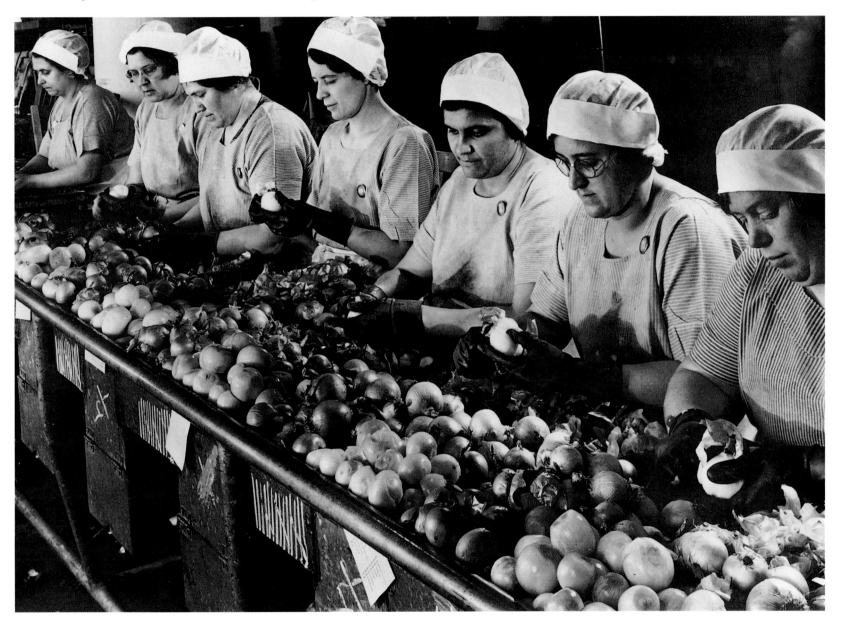

Workers peel onions for Campbell's Soup. The story appeared in *Fortune* in 1935.

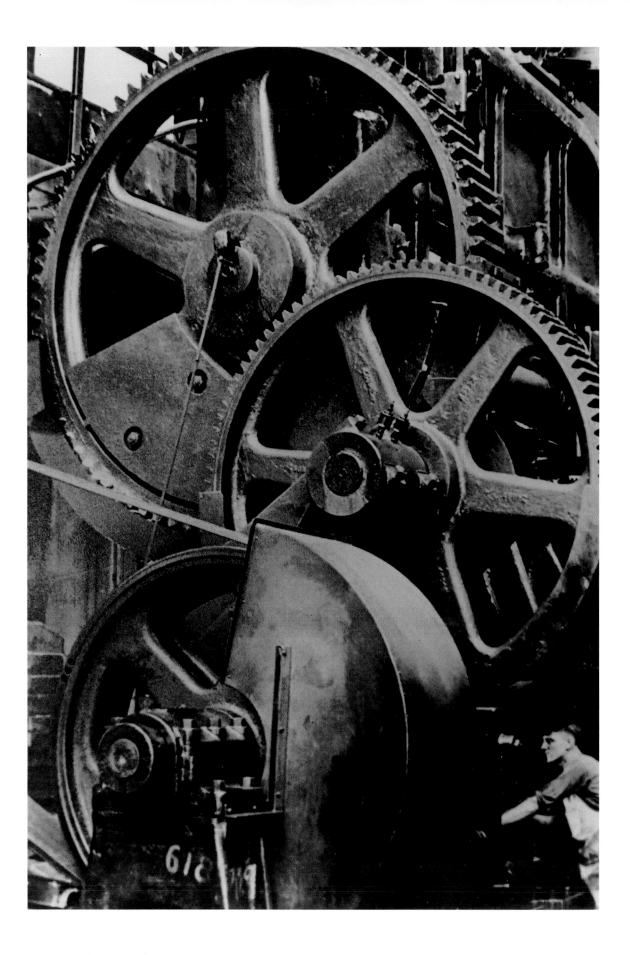

One of her independent projects was to photograph the Chrysler Corporation's manufacturing plants in Detroit. Walter Chrysler also commissioned Margaret to take pictures of his skyscraper under construction in New York City. He claimed it would be the tallest building in the world, but rumors had spread that the steel tower on top was nothing but an ornament, added to prove his claim. Margaret's job was to make "progress pictures" and to show that the tower was indeed an integral part of the building.

During the winter of 1929–1930 she took pictures of New York from eight hundred feet above the ground, often in subfreezing temperatures, on a tower that swayed eight feet in the wind. "I tried to get the feel of the tower's sway in my body," she wrote, "so I could make exposures during that fleeting instant when the tower was at the quietest part of its sway." Welders and riveters taught her how to relax and pretend she was only eight feet up. Heights did not scare Margaret. As a child, with her sister Ruth, she had walked to grade school on the tops of fences.

Now, working on the sixty-first floor of the Chrysler Building, Margaret fell in love with the strange stainless steel gargoyles. "I decided that here would be my new studio," she said and closed her Cleveland office. Her friend, John Vassos, a well-known industrial designer, decorated Margaret's penthouse studio in glass, wood, and aluminum. There was a tropical fish tank built into the wall. Margaret still enjoyed exotic pets and kept two alligators in an aquarium on the terrace, and a few turtles who roamed through the studio. Sometimes she crawled out onto the gargoyles, "which projected over the street 800 feet below, to take pictures of the changing moods of the city."

To pay for her expensive studio, Margaret began to work in the field of advertising and hired a staff. Oscar Graubner, a photographer, was her darkroom technician and was to remain with her throughout most of her career. Graubner was a superb printer and has been called "her second pair of eyes." Peggy Sargent became her secretary and also stayed on for years, even though the turtles often nibbled the lettuce in her sandwiches. The small staff quickly expanded to eight as more and more commissions rolled in.

Stampers at the Chrysler Corporation. Margaret added the figure at the lower right for scale, to show the relative size of the massive machinery.

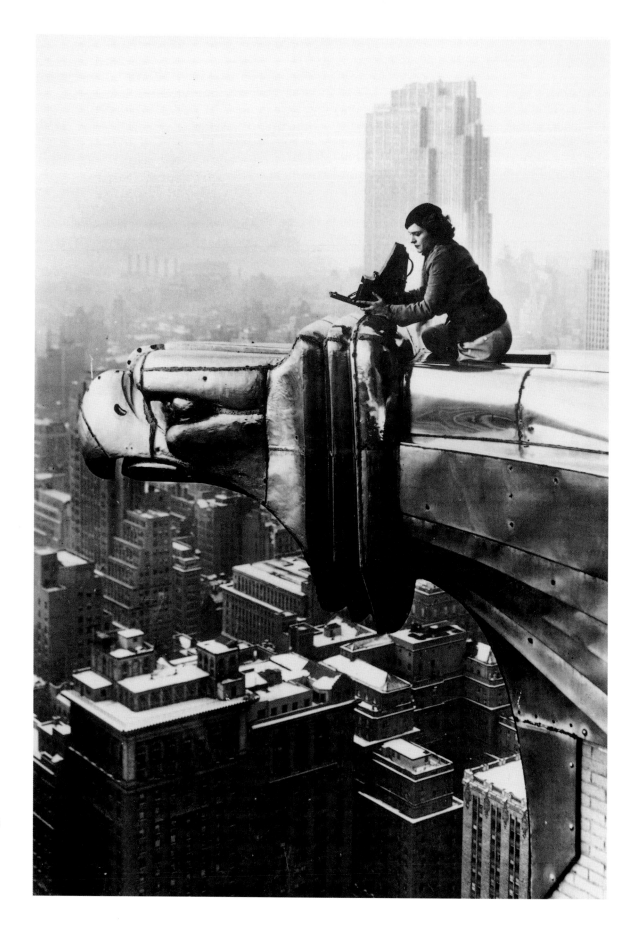

40

Oscar Graubner
photographed
Margaret as she
edged out on a
gargoyle at the
Chrysler Building
to photograph the
New York skyline.

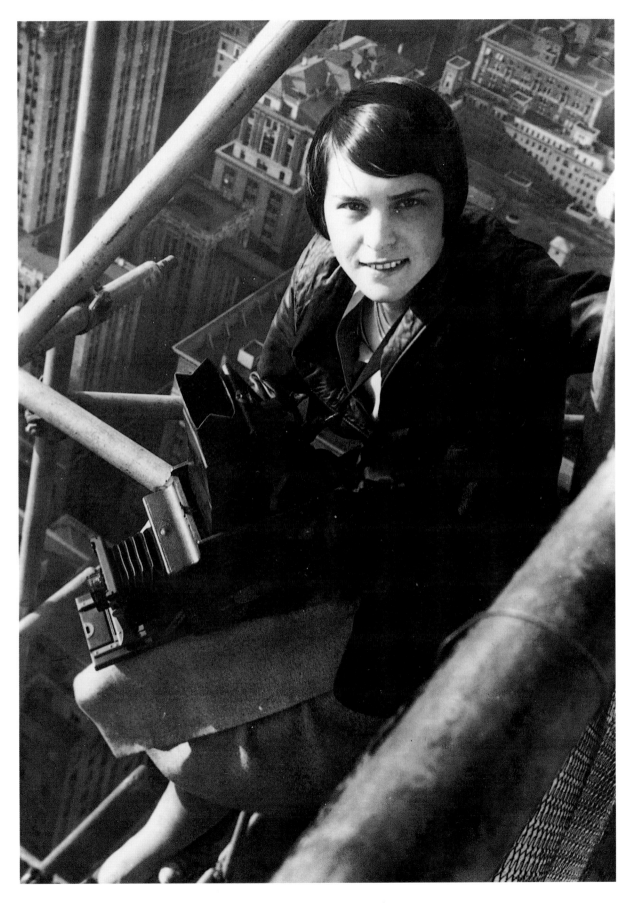

Margaret photographing construction of the Chrysler Building, New York, 1929. She uses a hand-held camera that does not need a tripod (photographer unknown).

Around this time color film became available. Technically it was more difficult to use. Margaret experimented with color film in her advertising photographs of pianos, gardens, and cosmetics. The pictures did not look as good as her black-and-white work, and she soon gave it up.

Margaret's best accounts were Buick and Goodyear Tires. Although she did not think she was a particularly great advertising photographer, she learned how to make the products look convincing. When she was not doing these assignments, Margaret worked for *Fortune*. In June 1930, the magazine sent her to Germany to take pictures of major industries. She desperately wanted to go to Russia, to photograph the agricultural nation as it industrialized. But no foreign photographers were allowed. Margaret wanted to be the first. "Nothing attracts me like a closed door," she wrote. She applied for a visa and was told that her industrial photographs would be her passport.

Something about her work must have attracted the Russian government, for Margaret's visa was granted. She had been warned that there was a food shortage in parts of Russia, so she prepared for her journey by packing a trunk with canned food, a can opener, and a teapot.

Indeed, on her arrival in Moscow, officials were so impressed with her industrial photographs, that she was made a guest of the Soviet government. In a few weeks Margaret took eight hundred exposures of mills, quarries, factories, and farms, trying to record her personal impressions "through the eye of the camera."

She went to see construction of the world's largest dam, which had been built over the Dneiper River. There she climbed steel beams and scaffolding to get her shots. In the textile factories and steel mills, she "prowled around," looking for interesting faces and viewpoints, "standing on tiptoe here, stooping there, peering between her hands to divide the scene into squares."

One of her most charming pictures was a portrait of *An Iron Puddler*. His job was to melt pig iron in a furnace and convert it into wrought iron. He loved having his picture taken, and when Margaret set up her camera and lights, he winked at her. When she was done, he said, "*Spasibo*." Thank you.

Margaret changed as a photographer during this trip. The people behind machines became more important to her as subjects than the machinery itself. Sometimes she hesitated before recording the suffering and hardship she saw—a twelve-year-old boy hauling a sledge hammer in a steel factory, a young man and woman pushing huge tractor wheels in another factory, families bundled up in ragged overcoats, waiting to be seen in a clinic.

Upon Margaret's return to the United States the publishers of Simon and Schuster, Dick Simon (a photography enthusiast himself) and Max Schuster, came to her studio to see her pictures and told her they thought she should do a book about the country. She did, and *Eyes on Russia* was published in 1931. Margaret dedicated the book to the memory of her father.

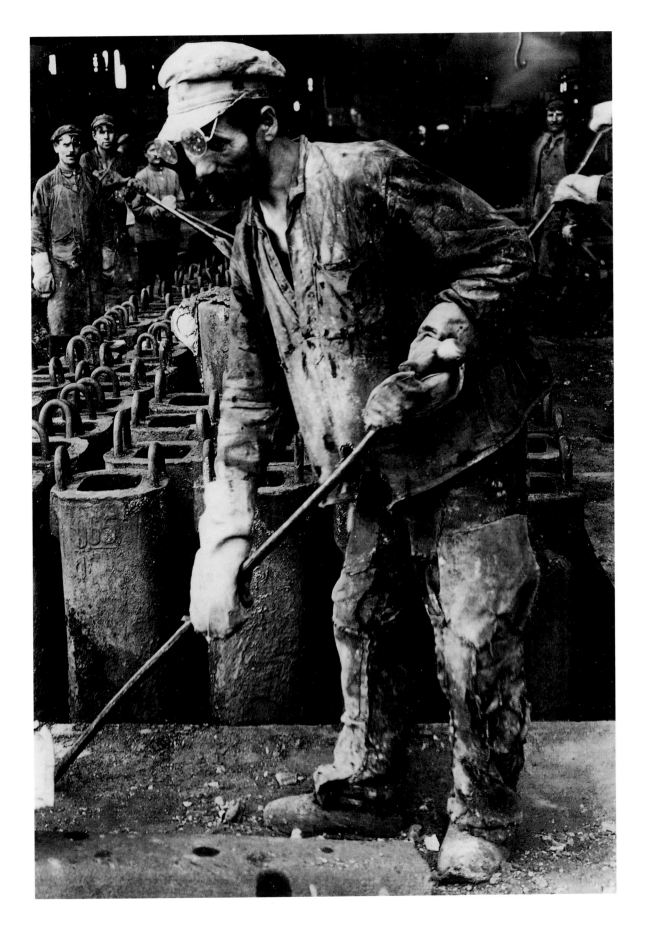

An Iron Puddler,
Stalingrad, 1930

That summer, the Russian government invited her to return. This time she focused even more on people, especially children. One of her most tender photographs is *Nursery in Auto Plant*, taken at a day-care center.

At home, her Russian photographs brought her a wider audience. Margaret began lecturing, and appeared on radio shows. In one interview, arranged by *Mademoiselle* magazine, she was asked what her next goal was. Margaret answered, "You'll laugh when you hear I want to do a children's book some time with pictures and text of reptiles—but such lovely ones that the children will no longer be afraid of them."

In 1934 *Fortune* sent her to the Midwest to cover the terrible conditions of the Drought. For years land in an area known as the Dust Bowl had been overplanted and overgrazed. Then, when there were fierce winds and no rain, the topsoil turned into whirlwinds of dirt. Margaret chartered a plane and flew from the Texas Panhandle to the Dakotas, photographing "withered land," "rivers of sand," and "dying cattle choked and blinded by dust." The suffering of the farmers and their families moved her deeply, as had the misery of the Russians. This assignment marked another turning point in her career.

Nursery in Auto Plant, Moscow, 1931

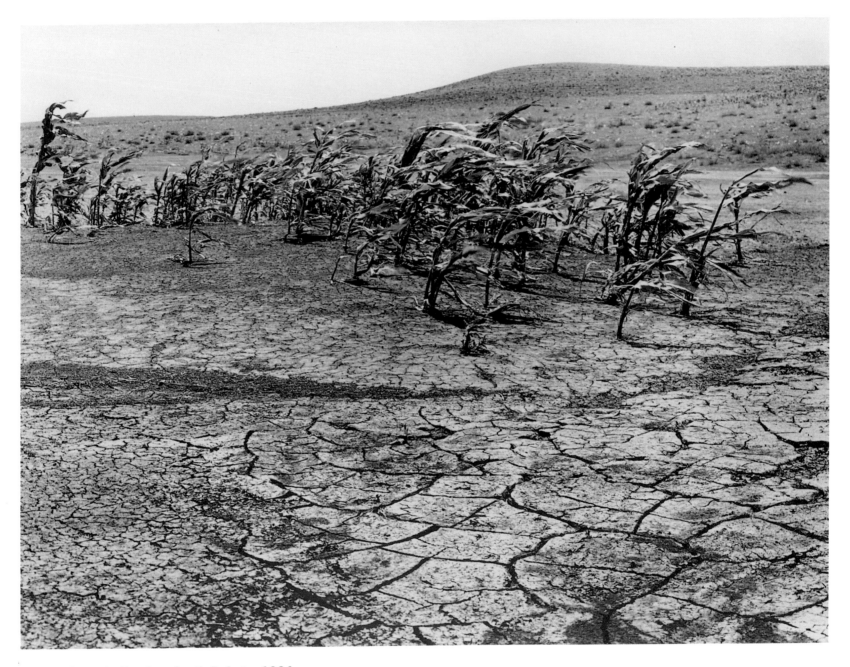

Drought Erosion, South Dakota, 1934

"I think this was the beginning of my awareness of people in a human, sympathetic sense as subjects for the camera," she wrote. "Suddenly it was the people who counted." Her feelings became even stronger when she returned to the same place, the following year, to photograph the dust storms. She saw children put to bed with towels over their heads to protect them from the airborne dust, and newborn calves dying because their lungs were caked with it.

When Margaret came back to New York, she felt that as an artist she was "seeking a wider world." One night she dreamed that "great unfriendly shapes" were rushing toward her, threatening to "crush her down." As the shapes drew closer, she recognized them as the Buicks she had been photographing. She ran away from them in her dream and woke up on the floor. She had fallen out of bed and strained her back. That day Margaret decided to quit advertising photography, even though a tempting call came in soon after with an offer to pay her more than she had ever been paid before.

Her *Fortune* assignments had introduced her to "all sorts of American people," and she wanted to do a book about them. But she felt she needed to collaborate with a more experienced author.

At a party in January, 1936, she made a point of meeting the agent of Erskine Caldwell, the noted novelist and playwright. (According to Caldwell, he instructed his agent to approach her.) Caldwell had written *Tobacco Road* about poor people in the rural South, where he had grown up. Nobody believed things could be as bad as Caldwell described, and he wanted to prove it with a documentary book illustrated with photographs. He realized that he needed a professional photographer. Caldwell and Margaret began to correspond about a possible project. They set a date to begin on June 11.

Margaret busily closed her advertising accounts. However, she had to complete an assignment for Eastern Airlines to photograph, from a smaller plane, their plane flying over New York. She usually asked friends to pose as the passengers and this time invited her mother to come along.

Minnie was in New York, attending summer school at Columbia University. On the first day of class she excitedly excused herself, saying, "My daughter is going to take me for my first airplane flight." Suddenly she fell to the floor, unconscious. Minnie had suffered a heart attack. She died two days later. Margaret's secretary, Peggy Sargent, said that Margaret did not seem very upset. Yet when Margaret wrote about her mother's death in her autobiography, she said, "I suffered a great personal loss. It was hard to imagine Mother ever would die. She was so vital and buoyant, so full of plans and interesting ideas."

Margaret carried on with her own plans just as she had done when her father had died. She took off for Wrens, Georgia, determined to do the book with Caldwell.

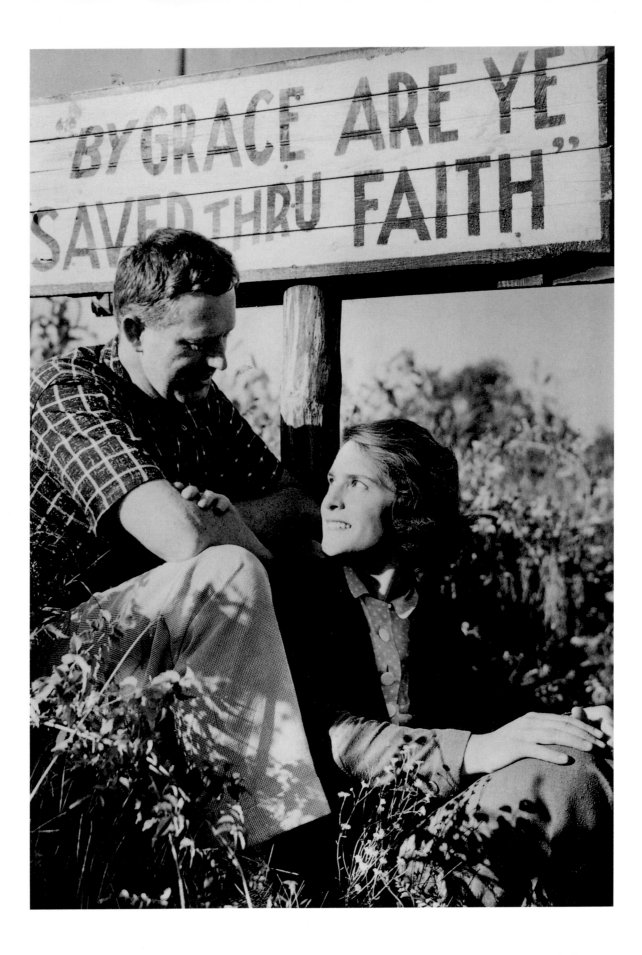

Chapter Five
A NEW POINT OF VIEW

Margaret and Caldwell did not get along at first. She had brought along suitcases filled with five bulky cameras, lighting equipment, boxes of flashbulbs, tripods, and of course, clothes that took up nearly all the room in the car. Most important to her, but most irritating to Caldwell, were two glass jars containing praying mantis egg cases, which she carefully put in the trunk. Still interested in science, she planned to photograph the life cycle of the praying mantis. Since she did not know when the insects would hatch, she took them with her.

On the first day of the trip while she was "tucking them in so they would ride smoothly," the lid of the trunk came down on her head. For the first time Caldwell laughed and said, "I hope something funny happens every day like a trunk lid coming down on Margaret's head."

She was glad to at least see him laughing, and by the fifth day they finally became friends. Caldwell introduced Margaret to a new way of working. As they visited farmers and poor families in the deep South, his home ground, he chatted and struck up friendships. People trusted him because he was a Southerner. Meanwhile, Margaret, a Yankee, hovered in the background with her camera, trying to remain inconspicuous as she took pictures.

Sometimes Margaret and Caldwell were invited inside peoples' homes. She was struck by the frugal way sharecroppers in Louisiana papered their rooms with old newspapers and ads from magazines. She would have been embarrassed to spot one of her own ads for a luxury item on these barren walls.

Since there was no electricity in most of the homes, Margaret lit interiors with flashbulbs operated from

Margaret and Caldwell in sharecropper country while working on *You Have Seen Their Faces* (photographer unknown).

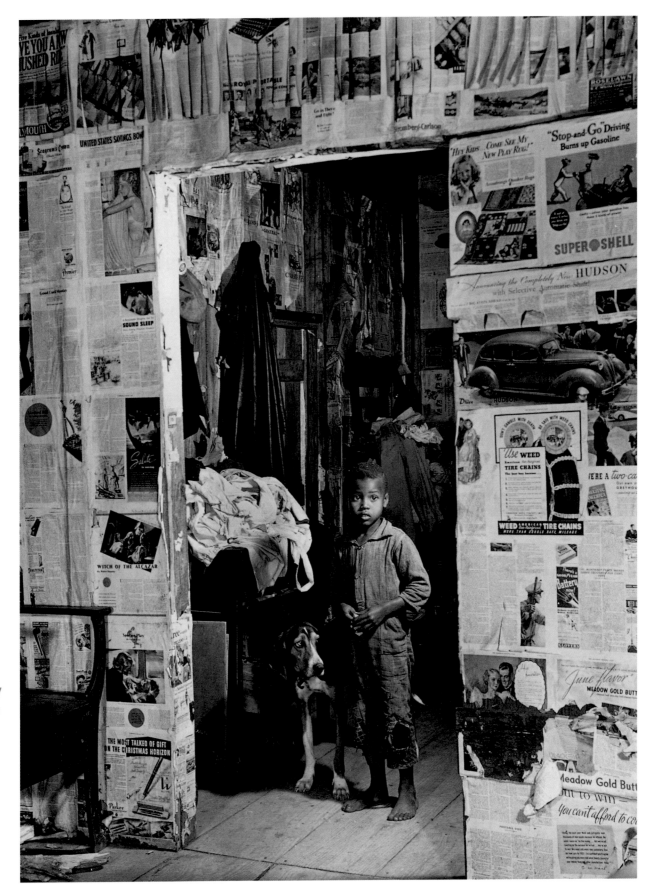

East Feliciana Parish: a boy poses for his picture with his dog, Blackie. From *You Have Seen Their Faces.*

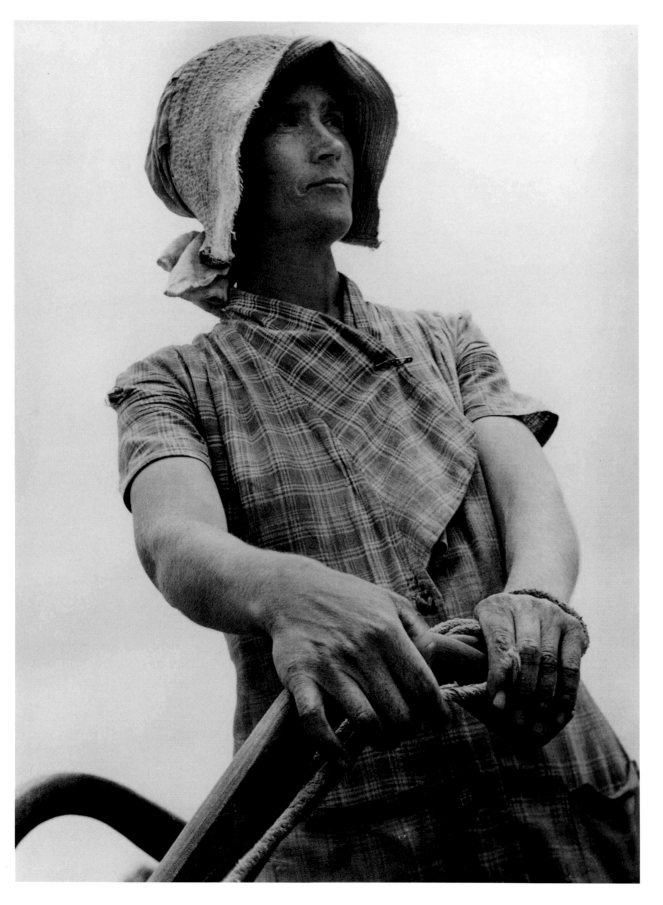

Hamilton, Alabama: "We manage to get along." From *You Have Seen Their Faces*, 1937. Margaret shot upward, at an angle, emphasizing the woman's strong weathered hands, in the foreground, and her beautiful face.

batteries. "Sometimes I would set up the camera in a corner of the room," she wrote, "sit some distance away from it with a remote control in my hand, and watch our people while Mr. Caldwell talked with them. It might be an hour before their faces or gestures gave us what we were trying to express, but the instant it occurred the scene was imprisoned on a sheet of film before they knew what had happened." She became expert at this kind of "posed candid shot."

Other times Margaret would direct the action, telling people where to sit and what to do. "She was almost like a motion picture director," Caldwell remembered. Once she took a picture of a woman combing her hair at a bureau made out of an old wooden box. Before taking the portrait Margaret rearranged the objects on top of the bureau. Afterward, Caldwell scolded her. He told Margaret she should have left everything just the way she found it to reflect the woman's taste and personality instead of her own. "This was a new point of view to me," Margaret wrote in her autobiography. "I was learning that to understand another human being you must gain some insight into the conditions which made him what he is."

Another time they managed to take pictures of a prison chain gang, despite the guard's objections. Margaret wanted to show the cruelty of this form of punishment. She jumped into the trench the men were digging and looked up at the gang, taking a close-up of the chains and a spoon tucked into an iron ankle cuff.

On the road she kept checking her precious praying mantis egg cases. One day the first baby mantis slithered out. Margaret set up the jars on a split-log fence and started to photograph them. A group of children gathered to watch and excitedly shouted, "Look at the little devil horses." She was charmed to learn this new name for her insects.

Back in New York, Margaret and Caldwell wrote the captions for the pictures. The book was called *You Have Seen Their Faces*, and was published by Viking Press, (already Caldwell's publisher) eighteen months later, in November 1937.

A reviewer for the *New York Times* said, "I don't know that I've ever seen better photography." But some critics, especially conservative Southerners, blasted the book as "sentimental slush," and accused Caldwell of writing propaganda. The photographer Dorothea Lange and her husband, Paul Schuster Taylor, who a few years later published a similar book about the problems of sharecroppers, criticized Margaret and Caldwell for writing the captions themselves rather than quoting the words people actually said. Photographer Walker Evans and author James Agee who were about to bring out their own book about harsh conditions in the South, angrily charged Margaret and Caldwell with exploiting the people they photographed. Publication of Evans' and Agee's book, *Let Us Now Praise Famous Men*, had to be postponed because *You Have Seen Their Faces* offered too much competition. Yet other photographers, such as

Hood's Chapel, Georgia: "They can whip my hide and shackle my bones," wrote Margaret and Caldwell, "but they can't touch what I think in my head."

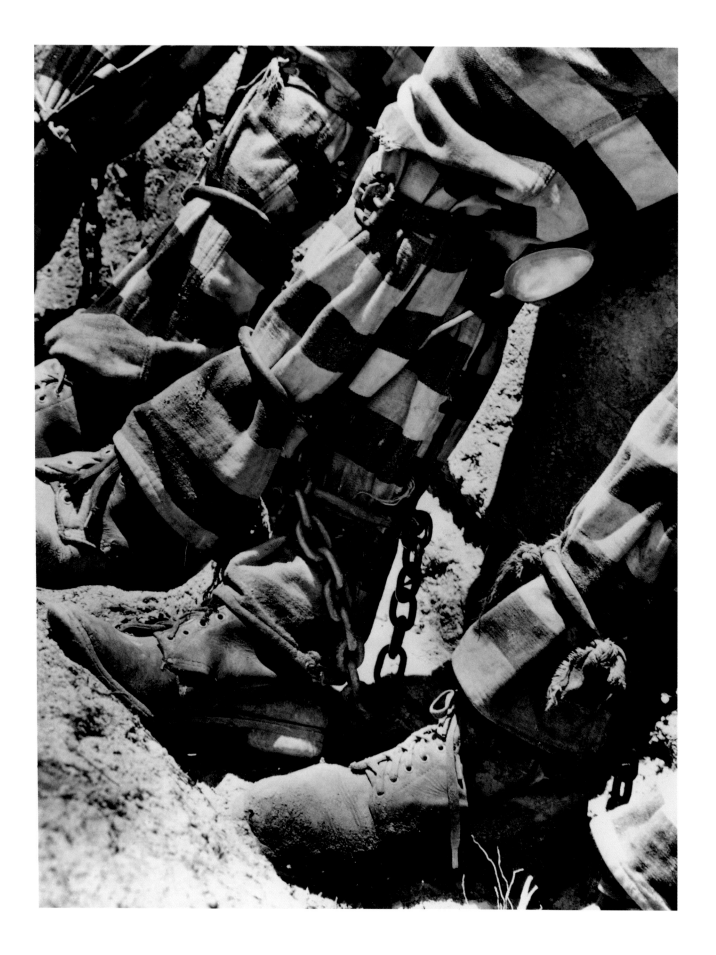

Gordon Parks, who worked in a documentary style, felt inspired by Margaret's innovative use of the camera in *You Have Seen Their Faces*. The book sold well and led to legislation that helped the sharecroppers.

Before Margaret had left on the trip with Caldwell, she had agreed to work on a new magazine that her editor, Henry Luce, was starting. It would feature national and world events in photographs. The photographs would be more than illustrations—they would tell the news. In September 1936 Margaret closed her studio in the Chrysler Building and moved to the offices of the new magazine, called *Life*.

Only three other photographers were hired—Alfred Eisenstaedt, Peter Stackpole, and Tom MacAvoy. They were called The Founding Four. The men used small 35 mm cameras to take spontaneous candid shots, while Margaret stuck with her big, old-fashioned cameras—the 4 x 5 Linhof, Soho, and Speed Graphic, a press camera. These were good for taking her carefully posed compositions, even though they were heavy to lug around.

From the start Margaret was given special treatment. She was the only staff photographer to have her own office, secretary, darkroom, and printer. Her printer, Oscar Graubner, soon became head of the *Life* photo labs, and her secretary, Peggy Sargent, became the magazine's film editor. Eisenstaedt said that Margaret was not very well liked and was friendly with

only a few people at *Life*. "She was a little bit bossy," he remembered. But everyone recognized her as a great photographer. Peter Stackpole, who was only twenty-three, was in awe of Margaret. "When she got absorbed in a subject nothing would stop her," he said. "Getting the picture was the thing. She was the hardest working woman I've ever met."

For Margaret's first assignment, Henry Luce sent her to Fort Peck, Montana, to photograph construction of the world's largest earth-filled dam. Margaret took monumental pictures of the dam, but to everyone's surprise, she also shot a human-interest story on the life of the workers. She showed the shanty towns they lived in and the bars where they drank and danced on Saturday nights. Her piece on the towns around Fort Peck was chosen as the lead story for the first issue of *Life*,

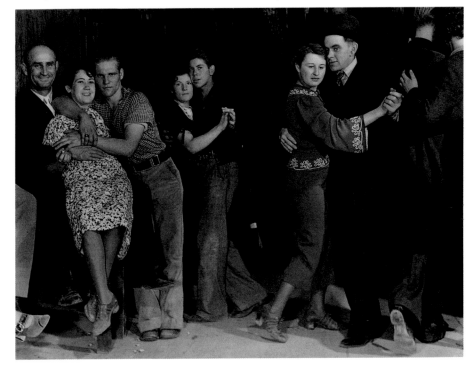

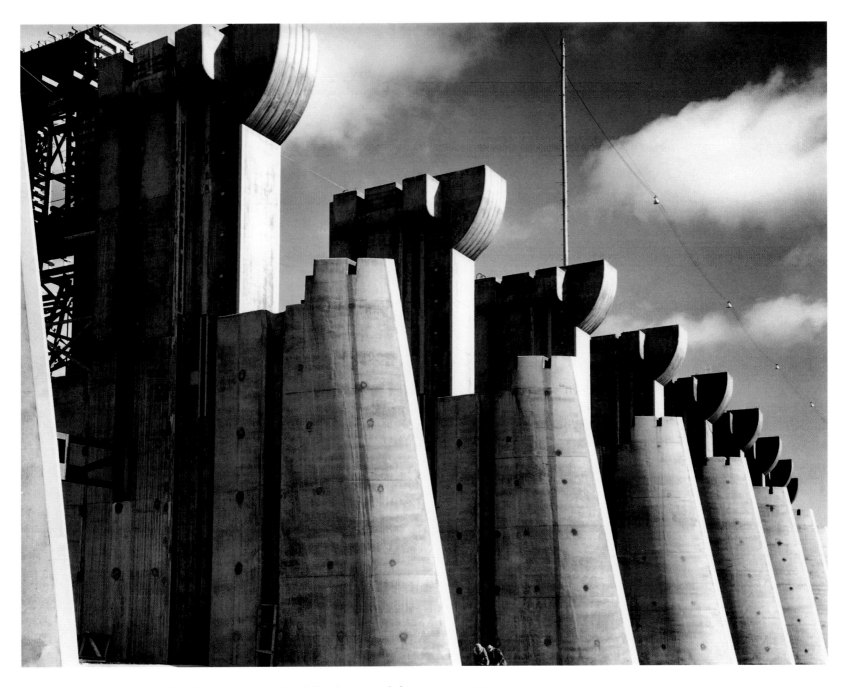

Opposite page: The first lead story for *Life* shows taxi-dancers, women who earned five cents a dance in the saloons in Fort Peck, Montana.

Above: *Fort Peck Dam, Montana.* First issue of *Life*, 1936.

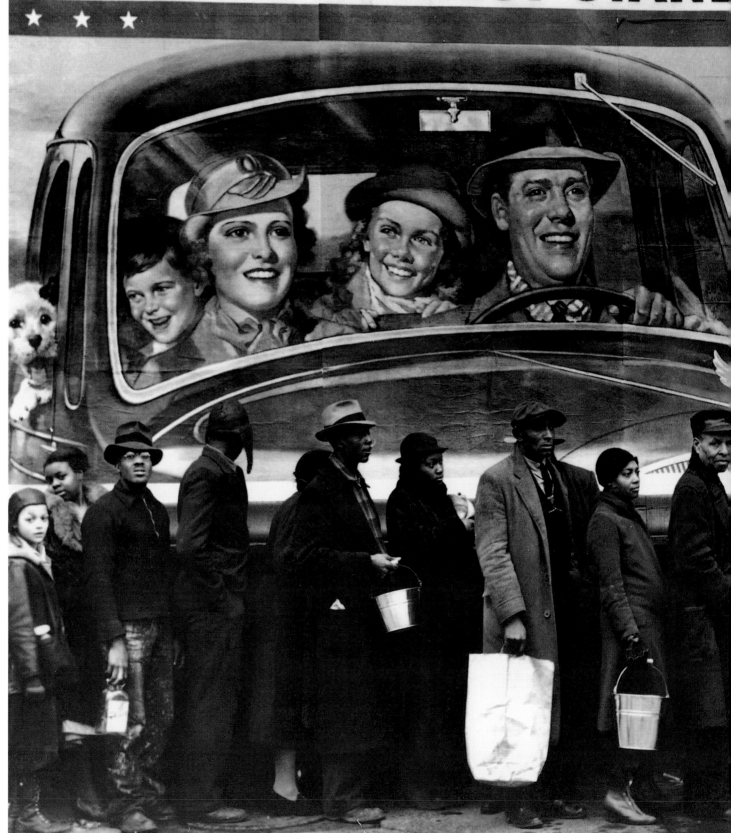

56

WORLD'S HIGHEST STAND

Bread line during the Louisville flood, Kentucky, 1937

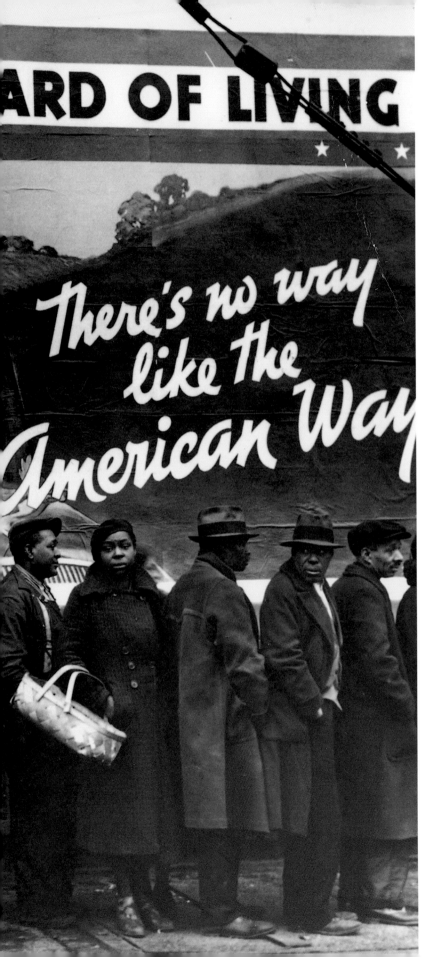

November 23, 1936. Her photograph of the dam appeared on the cover. The picture had been cropped by the editors. They cut her horizontal picture in half to get rid of some unfinished construction on the left-hand side, and also to show a more powerful image of the repeating forms of the dam. From that time on, Margaret insisted her negatives be printed in full, just as she composed them. Black ragged borders on the film indicated the edges of her pictures. The practice was called "printing black" and became the custom for everyone in the lab. However, if a certain image needed to be cropped to attain a more dramatic effect, Margaret did it herself.

Life was an instant success. The entire press run sold out within hours of hitting the newsstands. In those days, people waited eagerly for pictures so that they would know what was happening in the United States and around the world.

In the winter of 1937 Margaret went to Louisville, Kentucky, where the Ohio River had flooded, leaving thousands homeless. She took pictures from the rowboats and rafts that were delivering food and drinking water to marooned families. One of her best-known images is a photograph of flood victims lining up for supplies beneath a billboard illustration of a happy family. The slogan on the board read, "WORLD'S HIGHEST STANDARD OF LIVING—THERE'S NO WAY LIKE THE AMERICAN WAY." The contradiction between the billboard and the flood victims' situation creates an image that expresses a powerful message about injustice. Margaret moved the flood victims around and photographed them from different views until she had what she felt was the best composition to make the point.

One of her most interesting assignments was to cover President Franklin D. Roosevelt's annual trip to Warm Springs, Georgia, in November 1938. Roosevelt had contracted a severe case of polio in 1921 that crippled him and left his legs paralyzed. To help himself regain the use of his muscles, Roosevelt started visiting a run-down resort in Warm Springs. He found the mineral water so comforting and therapeutic that he bought the resort, restored it, and invited other polio victims to join him there. President Roosevelt went to Warm Springs every Thanksgiving for post-polio therapy, and to have dinner with his fellow patients. A few years earlier in 1932, Margaret had taken the President's portrait when he was inaugurated in Washington, D.C.

The night before *that* photo session she dreamed that her camera, tripod, and floodlights crashed, and that the President scolded her. Actually, the appointment went smoothly. However, afterward, when she was outside taking exterior photographs of the White House, she accidentally knocked the camera over with the back of her hand, and it really did break. "Wouldn't it be nice if I could tell the President of the United States my dream?" she often thought.

Her chance came in Warm Springs. Part of her assignment was to photograph the interior of the President's cottage, called the "Little White House." As she was leaving, she had the nerve to ask President Roosevelt if she could tell him about her dream. He smiled and said, "Yes, go ahead." When he heard how she had smashed her camera after taking his picture, he was fascinated. "'You just had to break a camera because you dreamed

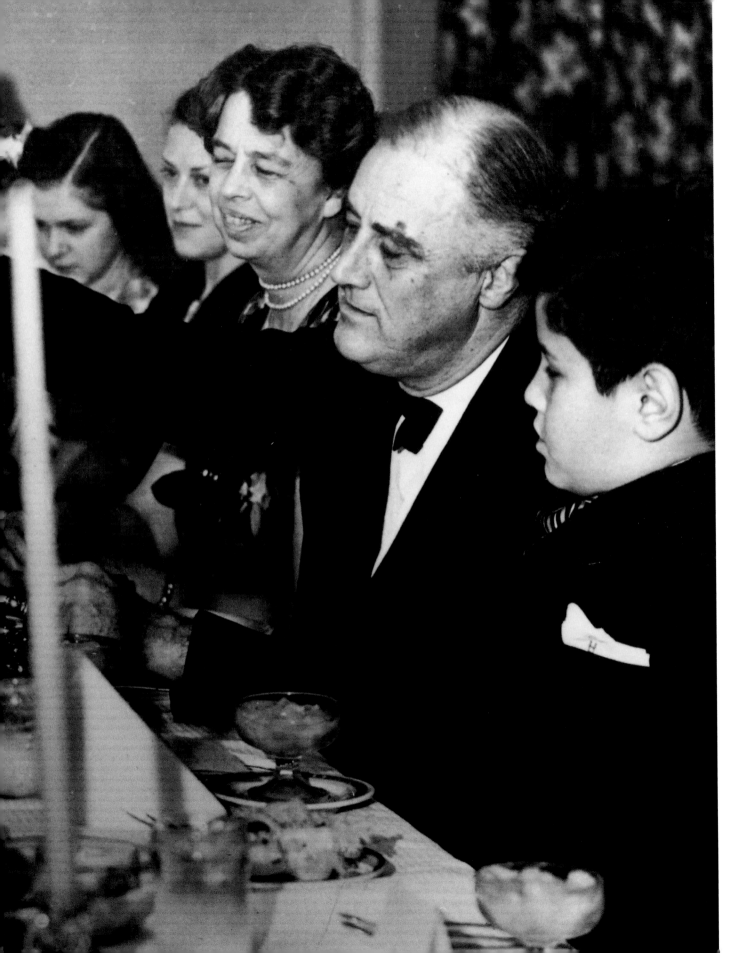

59

Every
Thanksgiving
patients at the
Warm Springs
Foundation drew
lots to sit at the
President's table.
Pictured here in
the seat of honor,
to the left of
Eleanor and
Franklin Delano
Roosevelt,
is Robert
Rosenbaum,
age eleven.

you would,'" he said, laughing heartily, then added, "'It was my face that broke the lens.'"

When assignments involved people and happenings in Washington, D.C., and especially the President himself, photographers fought for space to take their pictures. Margaret always used her nerve and wits when she jockeyed for position at these news events. Sometimes she literally crawled between the legs of her competitors (usually men), popping up at the last minute to catch "the caterpillar view." Photographers at *Life* competed fiercely to get good assignments and have their pictures published. Many of them envied Margaret's success. Being the best did not make her popular.

Once while she was away on an assignment, her colleagues played a terrible joke on her. Her office at *Life* was filled with insects, caterpillars, lizards, and fish. Margaret still loved studying nature. An exterminator, called in to fumigate one of the offices, was purposely misdirected to Margaret's. A colony of her praying mantis had hatched during the night, and there were thousands of insects everywhere. The exterminator killed them. No one ever dared tell Margaret it was not an accident. When she returned, she raised a new batch, and her story "Life Cycle of the World's Ugliest Insect" was published in *Life* in 1939.

She was in the middle of studying the life cycle of the mourning cloak butterfly when she was sent to the Arctic Ocean to join Canada's new Governor General, Lord Tweedsmuir, as he toured his lands. Lord Tweedsmuir was better known as John Buchan, author of the thriller *The Thirty-Nine Steps* and dozens of biographies and historical novels. Margaret had read the thriller and was excited about the assignment. Her butterflies were in the chrysalis stage, and she didn't want to miss getting pictures as they hatched. So she packed them in a case of peanut flashbulbs and took them along. Peanut flashbulbs were very small bulbs that put out a lot of light immediately, then burned out. Unlike today's electronic flash, they could only be used once. Therefore, Margaret had to have many of them on hand.

After she joined Lord Tweedsmuir on his steamship, she watched over her chrysalises. One Sunday morning, in the middle of Great Bear Lake near the Arctic Circle, the first chrysalises started to split open. The captain stopped the ship, as he had promised to do, so that Margaret could take her pictures undisturbed by vibrations of the ship's engine. "At the end of twenty minutes," she wrote in her autobiography, "we had ten beautiful mourning cloak butterflies." Only four survived, and she set them free at Tutoyakuk, on the edge of the Arctic Ocean, hoping they would live.

In the spring of 1938, before the outbreak of World War II, *Life* sent Margaret to cover the trouble spots in Europe: Spain and Czechoslovakia. It was a time of great turmoil. The German Nazi party was in power.

As a news photographer, Margaret hoped that her photographs would shape public opinion and perhaps change events. "It is my firm belief that democracy will

Praying Mantises, 1939

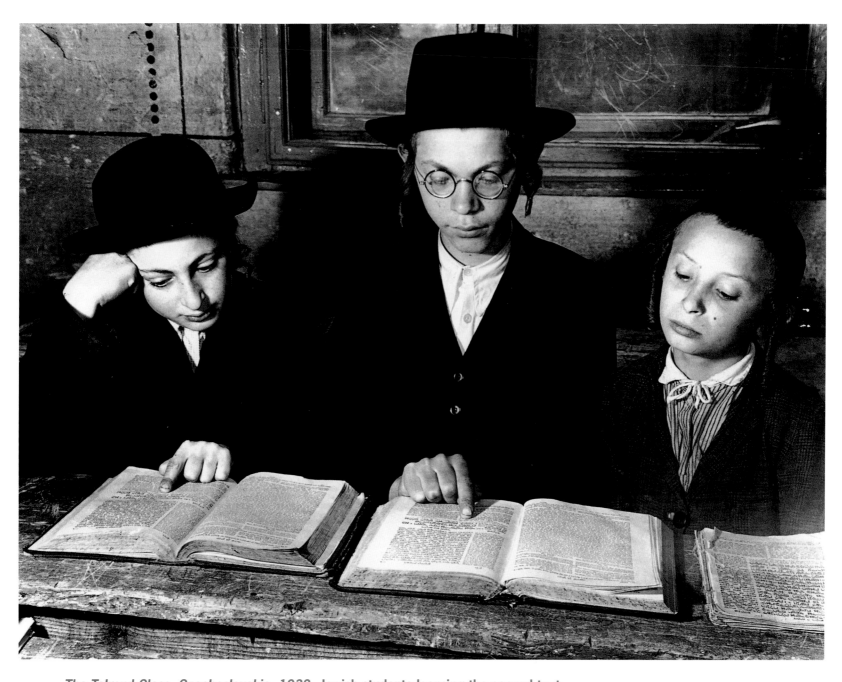

The Talmud Class, Czechoslovakia, 1938. Jewish students learning the sacred text.

not lose hold as long as people really know what is going on," she said in a radio interview. Because she was half Jewish (although no one knew), she was placing herself in a dangerous situation. Large numbers of Jews were being rounded up and put into ghettos and concentration camps.

Caldwell went with her to Europe and they stayed for five months, traveling through Czechoslovakia by train. They did another book together about this trip, called *North of the Danube*, published the following year. In the book Caldwell wrote about the many instances of anti-Semitism they observed. Margaret photographed young Nazi storm troopers, as well as orthodox Jewish boys at their studies.

When she and Caldwell returned to America, they were married, on February 27, 1939. They lived in a lovely house set in the woods in Darien, Connecticut. Before leaving Czechoslovakia, Margaret had taken pictures of evergreens in the Bohemian Forest. She had the photographs enlarged to form a floor-to-ceiling mural mounted to her living room and dining room walls. "So it is trees inside and out," she said.

Margaret was very happy and even thought of starting a family. In the meantime she and Caldwell bought Maine coon cats, an unusual variety with six or seven toes. They named them Suzy, Fluffy, Johnnie, and Lottie, and she thought of them as her children. However, soon Margaret had to leave them. When peace negotiations between England and Germany failed, war broke out. In October 1939 *Life* sent Margaret to Europe to cover the war.

64

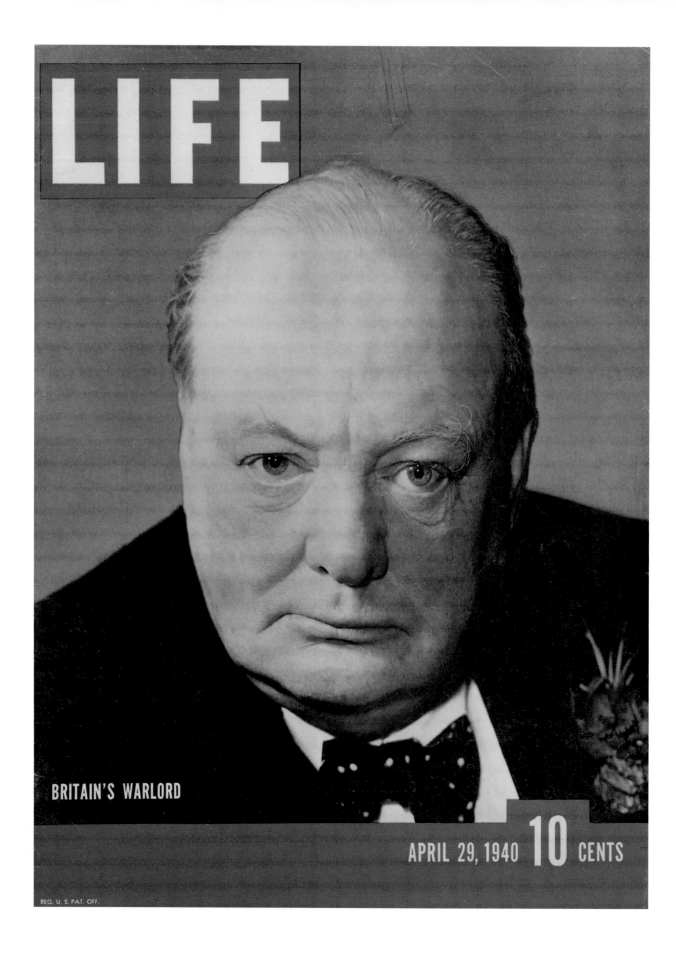

Chapter Six
ASSIGNMENT FOR *LIFE*

During World War II Margaret felt that she could make an important contribution as a journalist, telling stories with pictures. And like most good journalists, she had an uncanny instinct for where the story was.

In England she photographed Winston Churchill, then England's First Lord of the Admiralty and Chairman of the Supreme Defense Council. Her portrait of him appeared on a *Life* cover in April 1940 with the caption "Britain's Warlord." Two weeks later Churchill became Prime Minister. Margaret had taken the picture on his birthday, and in her notes described him as the most difficult subject she had ever had. He was "nervous and tired—understandably so, because the British Navy was having trouble with enemy submarines," and she was having trouble with a sticky shutter. (The shutter is the part of the camera that opens and closes to let in light. If it doesn't open at exactly the right time to let in exactly the right amount of light, the picture is overexposed and too bright.) Eventually, Margaret's portrait of Churchill came out perfectly and gave the public a direct face-to-face glimpse of the Allied leader.

Although Margaret's picture of Churchill made the cover, she was disappointed that *Life* printed only one of her photographs for a piece about the German air raids on London. By the time she had been gone for five months, Caldwell asked her to come home. Margaret considered the idea. She had promised Dodd Mead, a New York publisher, to do a children's book on insects. She was also thinking of leaving *Life*. They were not printing enough of her photographs to make the separation from her husband worthwhile. And she had to ask

Winston Churchill. Cover of Life, April 29, 1940

to be given credits for her pictures. From Syria where she was doing a piece on the Bedouin troops in the desert, she cabled Henry Luce with her resignation. When she returned to New York in 1940 she started working for a new New York City newspaper called *PM*.

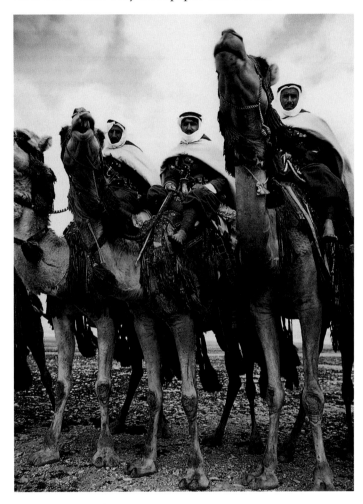

Bedouins formed a camel corps called *meharists* and were led by French commanders. Syria, 1940.

Margaret's nature studies of creatures such as the horned owl and golden eagle appeared regularly in *PM*. Yet she was not satisfied. The big news was happening in Europe. Hitler had marched through Paris, and German

bombs fell on London. By October Margaret was negotiating with *Life*, and they took her back. In March 1941 *Life* sent Margaret and Caldwell to Russia.

Wilson Hicks, *Life*'s picture editor, thought that the Nazis would attack the Soviet Union, although they had signed a nonaggression pact in the summer of 1939. Under the terms of the pact, Adolf Hitler, leader of the Nazis, and Josef Stalin, leader of the Soviets, agreed to help each other if their countries were attacked. They also divided up areas of Central Europe. Many people, including Hicks, doubted that Hitler would keep his word. For years Germany had been an enemy of the Soviet Union. Hicks wanted Margaret to be in Russia just in case his hunch proved right. Margaret took five cameras, twenty-two lenses, four portable developing tanks, three thousand peanut flashbulbs, and twenty-eight detective novels, adding up to six hundred pounds of luggage.

One of her goals was to go to the front if and when the fighting began. On June 22, 1941, German troops marched across the Soviet border. Margaret and Caldwell had been in the Ukraine and they hurried to Moscow. Their hotel overlooked the Kremlin and Red Square. The United States government wanted them to leave because it was so dangerous, but Margaret pleaded for permission to stay.

She was the only foreign photographer in Moscow when the first German bombs fell on July 19. Instead of going down to a shelter as she was told, she went up on the roof to take pictures. She said, "The opening air raids over Moscow possessed a magnificence that I have never seen matched in any other man-made spectacle. It was as though the German pilots and the Russian antiaircraft

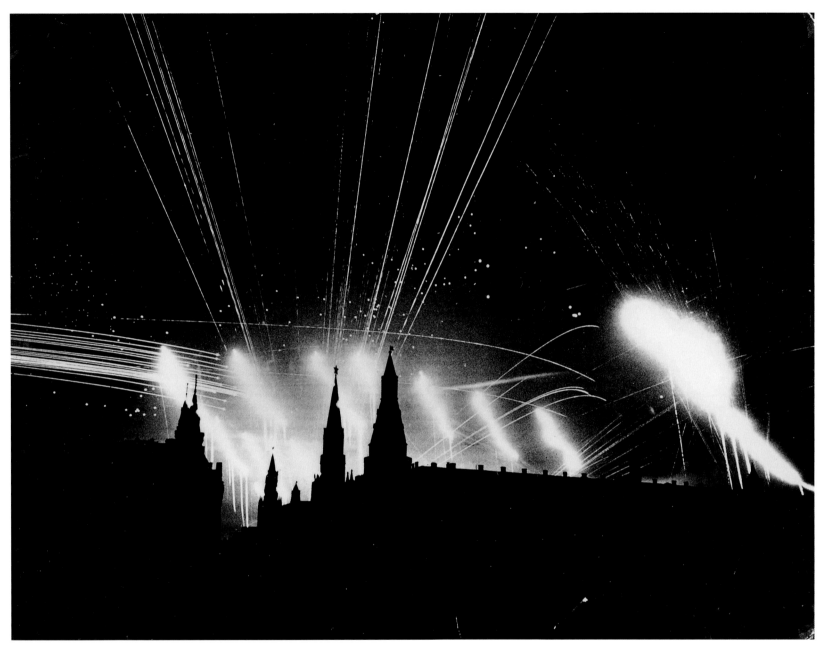

Bombing of Moscow, Summer, 1941. The Kremlin stands silhouetted against the light of parachute flares dropped by the Germans.

gunners had been handed enormous brushes dipped in radium paint and were executing abstract designs with the sky as their canvas."

For twenty-two nights Margaret risked her life taking photographs during the air raids and scooped or beat all the other publications. Her managing editor sent her a cable saying she was "MAKING A NEW REPUTATION BY FINE MOSCOW WORK."

Margaret had another goal: to photograph Josef Stalin. For months she had tried without success. Stalin had ruled the Soviet Union with total authority since 1927. He was known as one of the most ruthless tyrants of all time. Upon his orders millions of people were murdered in "purges." Millions more were arrested and sent far away to Siberia to work in forced labor camps. Stalin got rid of anyone who opposed him, or whom he even suspected of disloyalty. He hated Jews as well as intellectuals and educated professionals. So when Margaret succeeded in arranging to photograph him at the Kremlin on July 31, 1941, she must have been scared.

That night as she waited outside Stalin's office, she nervously checked her equipment, hoping that her cameras would work. She cleaned her lenses and tucked plenty of peanut flashbulbs into her pocket. Finally, she was shown into Stalin's office where he was meeting with the American representative of President Roosevelt. At first Margaret was amazed to find that Stalin was short and not at all like the gigantic statues of him that stood all over the Soviet Union. "What an insignificant man," she thought. Then she took a closer look and realized "there was nothing insignificant about Stalin. He made all the decisions." His face was "the strongest, most determined" she had ever seen. But she wanted her portrait to show more than Stalin's power. How could she put this dictator at ease and get him to loosen up? Although she had planned to ask him to sit down and chat and act natural, she knew she could not tell Stalin what to do.

A lucky accident occurred. As Margaret knelt to take a picture from a low angle, shooting upward, her pocketful of peanut flashbulbs scattered all over the floor. She and the Kremlin interpreter scrambled after them. Stalin evidently thought it was very funny and started laughing. In that moment he revealed another side of his personality, "genial and almost merry," and Margaret quickly snapped two exposures before his smile disappeared.

Later she carefully processed the precious negatives in a bathroom in the cellar at the American Embassy. There was another air raid that night, as there had been every night during July of that year, as the Germans attacked Moscow. Guns and bombs blasted outside while Margaret dried her negatives and developed the prints. By 5 A.M. the prints were ready and were flown to Washington, D.C., by diplomatic courier, and from there to the *Life* office in New York. The editors printed the photo of Stalin grinning in the September 8 issue and again on a cover in 1943 in an issue devoted to Russia.

Just before Margaret and Caldwell were to return home, they were given permission to go to the front where the most fierce fighting occurred. On the way to Yelna, the site of a bloody battle between thousands of German and Russian soldiers, their convoy stopped at a hotel. When a bomb fell directly across the street, Margaret dashed outside with her camera. Four members of a family lay dead. She took pictures. In her book *Shooting the Russian War* she wrote, "Days later, when

Josef Stalin, 1941. The Soviet leader breaks into a slight grin for Margaret. She was surprised to see that his cheeks were pockmarked since the scars were always retouched in Russian photographs.

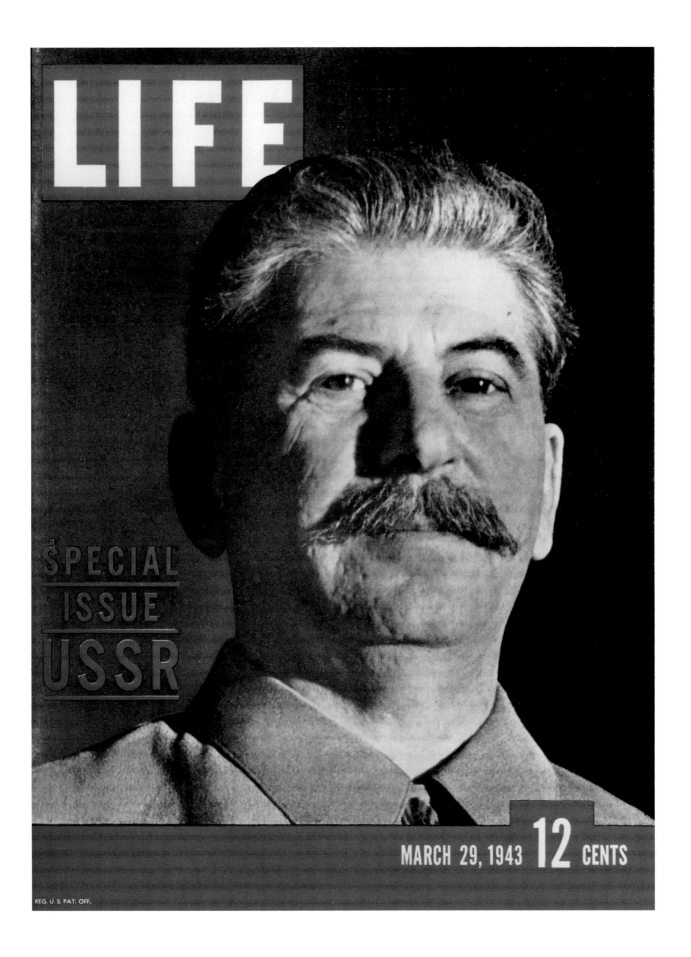

LIFE

SPECIAL
ISSUE
USSR

MARCH 29, 1943 **12** CENTS

REG. U. S. PAT. OFF.

I developed the negatives, I was surprised to find that I could not bring myself to look at the films. I had to have someone else handle and sort them for me."

Back in the United States, Margaret gave lectures on Russia and started work on her book. But after the United States entered the war in December 1941, Margaret asked *Life* for another overseas assignment. Her editors arranged to have her accredited to the U.S. Army Air Force. Now both *Life* and the Air Force used her pictures. The first uniform for a woman war correspondent was designed for Margaret, and she loved it. It had a jacket with gold buttons, like an officer's, war correspondents' insignia on the shoulders, and skirts as well as slacks.

Wearing her uniform, she returned to England and photographed the B-17 bombers known as The Flying Fortresses. While she waited for permission to go on a bombing mission herself, she received a cable from Caldwell saying that he wanted to end their marriage. The long separations due to her war work made him too lonely. In November 1942 Margaret agreed to a divorce. She wrote to her lawyer and said that all she wanted was the house in Connecticut. Margaret claimed to feel relieved now that she could devote herself completely to photography; however, those who knew her believed she was deeply upset. Although she had numerous romances, Margaret never married again.

With her typical drive and determination, Margaret threw herself into her work. To Wilson Hicks she wrote, "The work has always been first with me as you know. But now it is FIRST FIRST." In 1943 she went to Italy on assignment. Allied forces had driven the Germans out of North Africa and invaded Italy, which was then in control of the Nazi army.

A story about the Medical Corps in January 1944 took Margaret to a field hospital near the battle line. The hospital consisted of tents painted with red crosses. The Germans were stationed just a few miles away. As bombs fell during the night that Margaret arrived, she photographed surgeons in battle helmets operating by flashlight. Every time the shriek of a bomb sounded, the entire hospital staff, including Margaret, dropped to the floor. Then they got up again and continued their work. All through the night wounded and bleeding soldiers were brought in. More than half of them died. "Never have I seen such a night," Margaret wrote years later. "I knew I was getting dramatic pictures. If these men had to go through so much suffering, I was glad, at least, I was there to record it."

Afterward, as she headed for home, *Life* wanted to rush the film into print. But first the pictures had to be approved by the U.S. Department of Defense. All photographs taken by war correspondents were sent to the Pentagon for developing and censoring before they were released to magazines. When Margaret returned to New York, Wilson Hicks told her the bad news: a package of her hospital film had been lost at the Pentagon. Only one film package made it through. Margaret realized that the lost package contained her strongest photographs. She was so furious that she arranged to go to the Pentagon and search for the missing pictures herself. She never found them and *Life* only published the film they had.

At home in Connecticut Margaret started a book

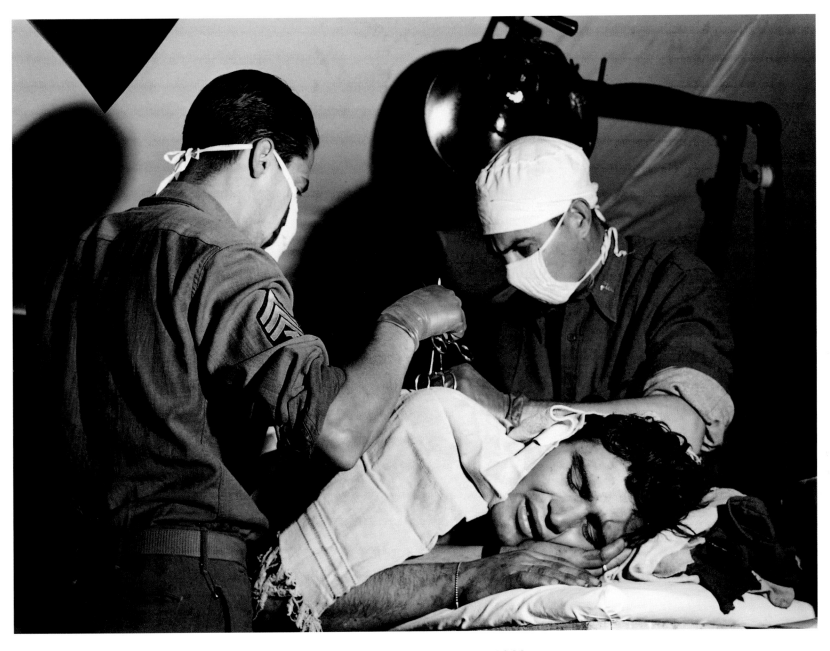

Doctors operate on a wounded soldier in an evacuation hospital in Italy, 1944.
"Of course it hurts, son," said the doctor. "Not much longer now."

about her experiences in Italy and titled it *Purple Heart Valley*, the name of the battle zone she had photographed. Meanwhile, the Allied troops landed in Normandy, France, on June 6, 1944, D-Day. Then the American, British, French, and Canadian troops drove across France and into Germany. The war was drawing to a close and Margaret wanted to be there when it did—what a story to capture on film!

In March 1945 she gained permission to fly to Frankfurt, Germany; there she photographed General George S. Patton, head of the 3rd Army, as he prepared to cross the Rhine. On April 11, General Patton's troops marched into Buchenwald just two hours after the Nazis fled. Buchenwald was the first concentration camp liberated by the Americans. Jews, political prisoners, and the disabled had been held there as slave labor and were starved to death or gassed. Americans had heard about the camps but did not believe they really existed or thought the stories were exaggerated. Photographs like Margaret's convinced them of the horrible truth.

When General Patton entered Buchenwald, he was so enraged at what he saw that he ordered his MPs to round up 1,000 citizens of the nearby town, Weimar, and forced them to witness what had gone on in their community. The MPs were so upset that they rounded up 2,000. German women fainted or wept. Men covered their faces and looked away. "We didn't know! We didn't know!" they repeated.

"But they did know," Margaret said. She took pictures of everything: German civilians viewing corpses heaped in piles, ovens filled with ashes of the dead, survivors lying in their bunks, too weak to walk or stand. Margaret's pictures revealed her intense anger at the Germans, and outrage at what they had done.

General George S. Patton, 1945. "Don't show my jowls," General Patton told Margaret. "And don't show the creases in my neck." She tried to do as he asked and afterward gave him a photography lesson.

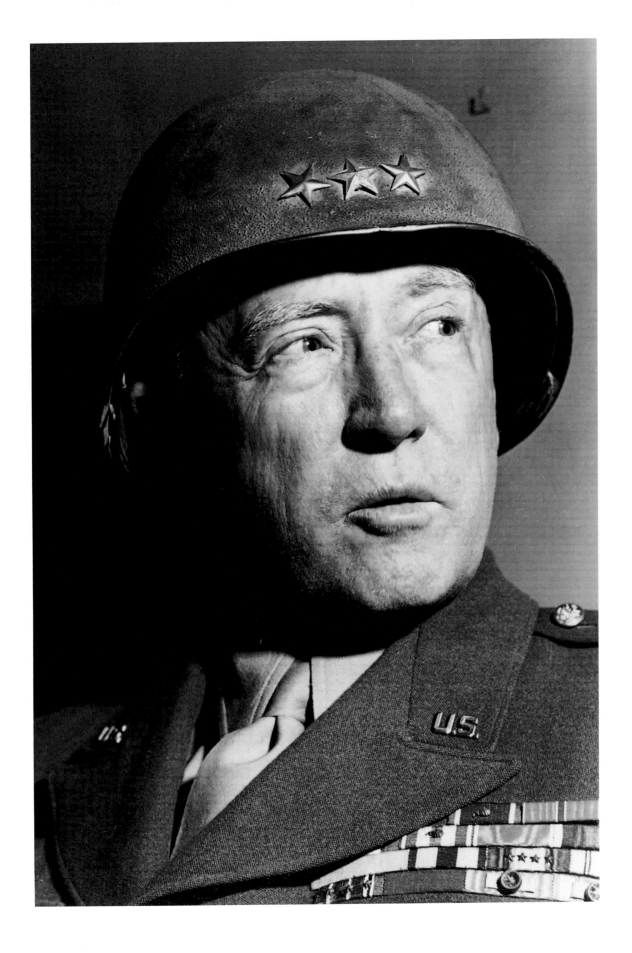

Her powerful image, *The Living Dead of Buchenwald*, has become one of the most memorable images of the twentieth century. "I had a deep conviction that an atrocity like this demanded to be recorded," she said. In order to tolerate the work, Margaret needed to distance herself emotionally. When people asked her how she could bear to photograph such things, she said, "I have to work with a veil over my mind. I hardly knew what I had taken until I saw prints of my own photographs." On May 8, 1945, the Germans surrendered and the war ended.

Within a few months, *Life* sent Margaret to a new trouble spot.

The Living Dead of Buchenwald, April, 1945

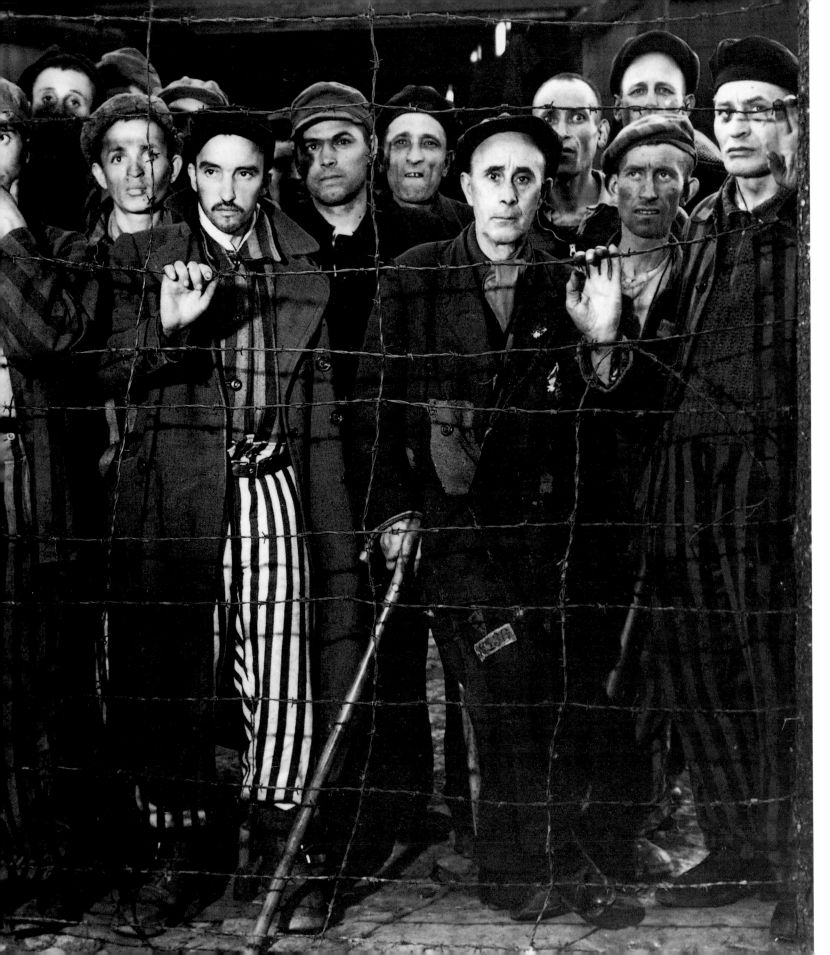

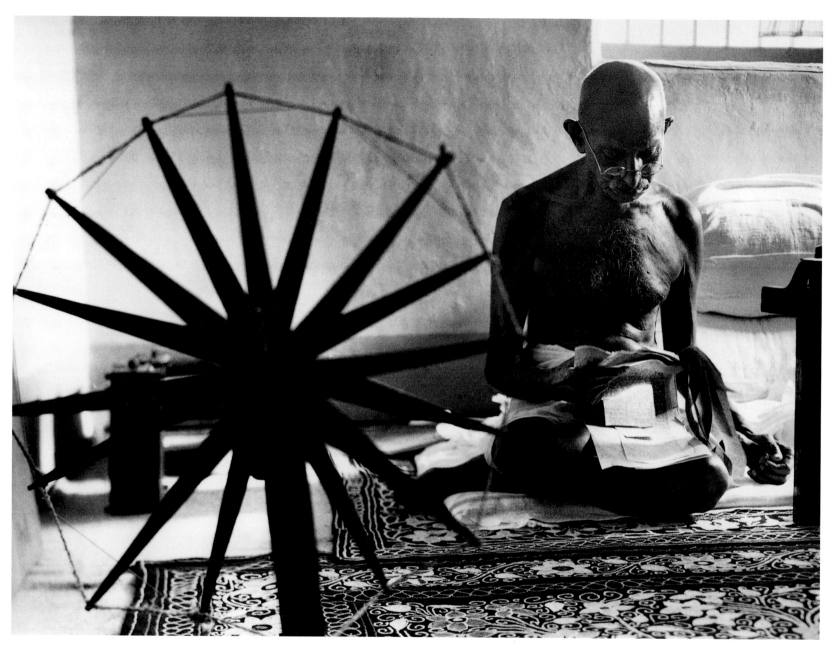

Mahatma Gandhi at His Spinning Wheel, Poona, India, 1946

Chapter Seven
RECORDING THE HORROR

In March, 1946, *Life* sent Margaret to India. The country had been under British rule for nearly two centuries and was about to become independent. The first thing Margaret wanted to do was to take the picture of India's leader, Mahatma (Great Soul) Gandhi. Gandhi was both a political and spiritual leader. He had fought for his country's freedom with the nonviolent methods of fasting, boycott, and prayer, and had chosen to live with the Untouchables, the poorest people.

When Margaret tried to get permission to photograph Gandhi, his secretary said she would first have to learn how to use the charka, a primitive spinning wheel.

"Oh, I didn't come to spin with the Mahatma," she said. "I came to photograph the Mahatma spinning."

The secretary said that she could not possibly understand Gandhi unless she knew how to work the charka. For Gandhi, it was a symbol of the fight for freedom. If his people could make their own homespun cloth, they would not need expensive cloth made by British machinery.

Margaret took a spinning lesson immediately. Clumsily she kept breaking or tangling the thread but finally succeeded in producing a serviceable one. She had earned the right to enter Gandhi's hut. There were more rules. She could not speak to him since it was Monday, his day of silence. And she could only use three flashbulbs because he did not like bright lights.

Inside, the hut was very dark and quiet. Gandhi sat on the floor reading the newspaper. Then he started spinning. Margaret said, "I was filled with an emotion as close to awe as a photographer can come." It was a perfect moment for a picture except that her first flashbulb did not work. Then she forgot to pull the slide to expose the film and wasted the second. But with the third she captured a portrait of Gandhi that became a classic piece of work. Her photograph conveys the very essence of

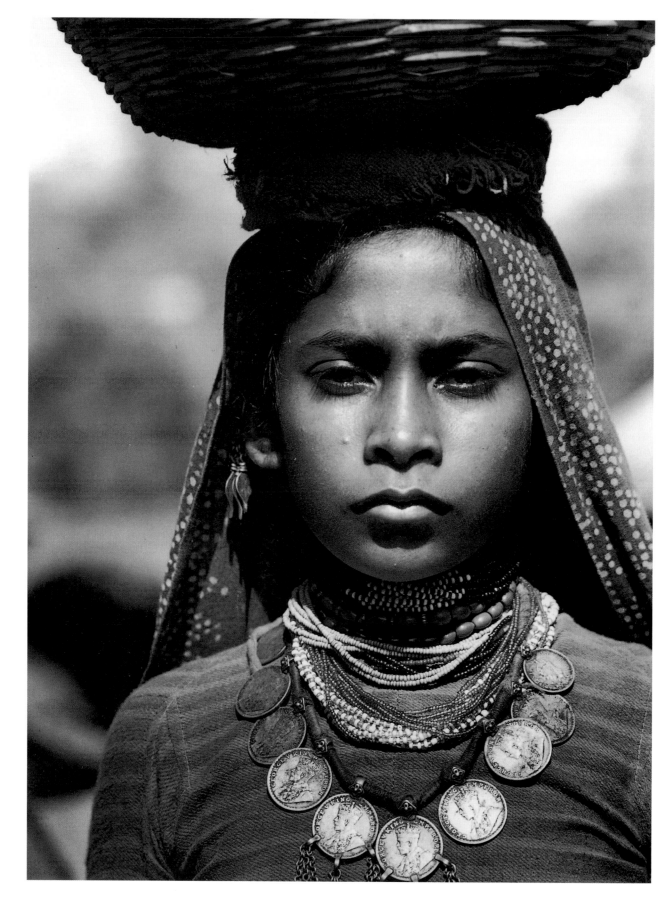

78

A Village Beauty, India. A young woman returns from the bazaar with a basket full of vegetables. All her wealth is in the jewelry she is wearing.

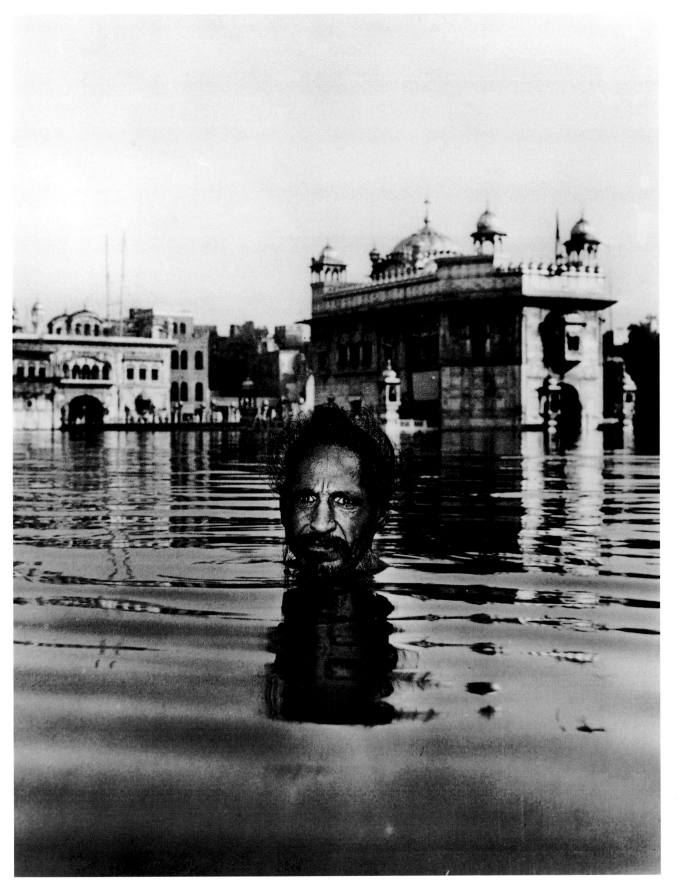

Sikh Bathing,
India, 1946.
A Sikh, member
of a religious
sect descended
from warriors,
bathes in
sacred waters.

Gandhi—gentle, peaceful, dedicated. Details of his simple hut tell about the man. In the foreground, his spinning wheel dominates the composition. He sits behind it, deeply absorbed in what he is reading, oblivious of Margaret and her camera.

Margaret often saw Gandhi and tried to take more pictures of him. Whenever she appeared with her cameras and flashbulbs, he joked, "There's the Torturer again."

She traveled with Gandhi and his followers when they went north for freedom talks with the British. India was divided into two factions, the Congress party led by Gandhi, a Hindu, and the Moslem League led by Mohammed Ali Jinnah. In September 1946, Hindus and Moslems clashed in four days of fighting and rioting. Thousands of people lay dead in the streets of Calcutta.

Margaret flew there from Bombay and found a scene that reminded her of Buchenwald. The stench was horrible. Bodies were rotting in the 95-degree heat. Vultures feasted on the corpses, stuffing themselves so full they were too heavy to fly. Margaret said, "I did my job of recording the horror and brought the pictures out for *Life*, but the task was hard to bear." The riots in Calcutta set off a chain reaction of violence in other parts of India that lasted for months. Finally, a year later, the country was divided, and Jinnah named his new country, Pakistan.

Margaret went home to Darien, Connecticut, and began writing *Halfway to Freedom*, a book about India. "Writing a book is my way of digesting my experiences," she explained in her autobiography. Her routine was to sleep outdoors on a piece of garden furniture, listening to the frogs in her pool and watching the fireflies. Then, at 4 A.M. she would wake up and start work.

Partway through her book, she realized she did not know enough to finish, so she returned to India. For five months Margaret traveled through the country meeting people. Her photo-essay for *Life*, "The Caste System," showed rich princes, moneylenders, bearded Sikhs, peasants, and Untouchables. The caste system was based on a person's status at birth, and that status could never change. Even though this system had been officially outlawed in 1947, prejudices lingered. Margaret despised the injustice she saw but felt it was her obligation to record it.

One of the worst situations she witnessed was child labor in a tannery. Children from Untouchable families processed cow hides in a lime vat. The lime ate away the flesh of their hands and bare feet, resulting in hideous deformities. "No one else will work with the skin of a dead cow," her guide told her. Margaret had to take pictures quickly before the owner of the tannery caught her. Sweat rolled down her face, and her eyes teared from the acid fumes.

Another horror Margaret recorded was the Great Migration sparked by hatred between religious groups. Now that India was divided into two nations, many people found themselves on the wrong side of the new borders of Pakistan and India, and were forced to leave their homes. Ten million people fled for their lives. It was the largest migration in history.

Margaret was reminded of the Book of Exodus as she followed in a jeep and took pictures. "There were heartbreaking subjects to photograph," she said. Many people died of cholera and exhaustion along the way. One of her most touching images is of an old Sikh carrying his wife on his shoulders.

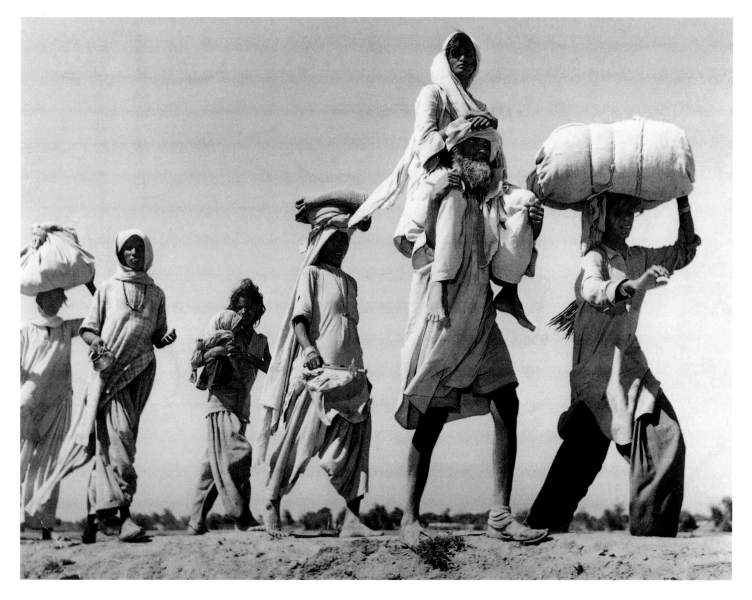

The Great Migration, Pakistan, 1947

On Margaret's last day in India, she arranged an interview with Gandhi. A few hours later, while he was on his way to evening prayer, Gandhi was shot by a Hindu fanatic and died. When *Life* ran the story "India Loses Her Great Soul," the editors reprinted the first picture Margaret had taken of Gandhi. "Nothing in all my life has affected me more deeply," she wrote, "and the memory will never leave me." Her reverence for Gandhi, and her empathy for the peasants and refugees was revealed in Margaret's art. Biographers and art critics have said that during this period she did some of her most beautiful, dramatic work.

With the experience she gained in India, Margaret felt ready for her next big story—in South Africa. *Life* sent her there at the end of 1949 to study racial conflicts. "On this assignment I had the feeling I was working at the summit of my powers," she wrote in her notes. "I used everything I had in the way of understanding, of photographic technique, of diplomacy."

Margaret hated the system of government called apartheid, or apartness in all things. Each racial group lived separately in ghettos. Three-quarters of the population were black, Asiatic, or mixed, yet they were the "minority" and had no power. The whites owned almost all the land, as well as the gold and diamond mines.

Margaret found herself in a dilemma. "What are you going to do when you disapprove thoroughly of the state of affairs you are recording?" she asked. "What are the ethics of a photographer in a situation like this? However angry you are, you cannot jeopardize your official contacts by denouncing an outrage before you have photographed it."

One Sunday she went to a gold mine and watched miners dancing in tribal costumes. Two miners seemed particularly graceful, and she chose them as subjects for her photo-essay. When she asked their names, she learned that black miners were considered units . . . known only by numbers tattooed on their arms, like prisoners in Nazi concentration camps.

The next day she put on mine clothes and a crash helmet and hung a whistle around her neck to use if she was trapped; then she descended two miles beneath the ground with the miners numbered 1139 and 5122. The air was so heavy and the heat was so intense that she felt strange and could not speak or raise her hands. Realizing she was in trouble, the superintendent rushed her to another part of the mine where there was better air. As soon as she revived, she went back to work. Her portrait of the two miners appeared on the title page of her photo-essay "South Africa and Its Problem" and became one of her favorite photographs.

In her story she recorded other situations that infuriated her. Blacks worked long hours in the diamond mines but earned only seventeen cents a day. At night they were locked up like prisoners behind barbed wire and guarded by vicious dogs. Margaret said repeatedly, "I hate gold and diamonds since I've been to Africa."

Blacks who worked as house servants lived in miserable shantytowns and were harassed by the police. Children and adults who worked in the vineyards were paid partly with "tots" of wine, and the children became alcoholics. "Nothing had made me so angry since I photographed 'untouchable' children working in the tanneries of South India," Margaret wrote.

Gold Miners, Nos. 1139 and 5122, Johannesburg, South Africa, 1950

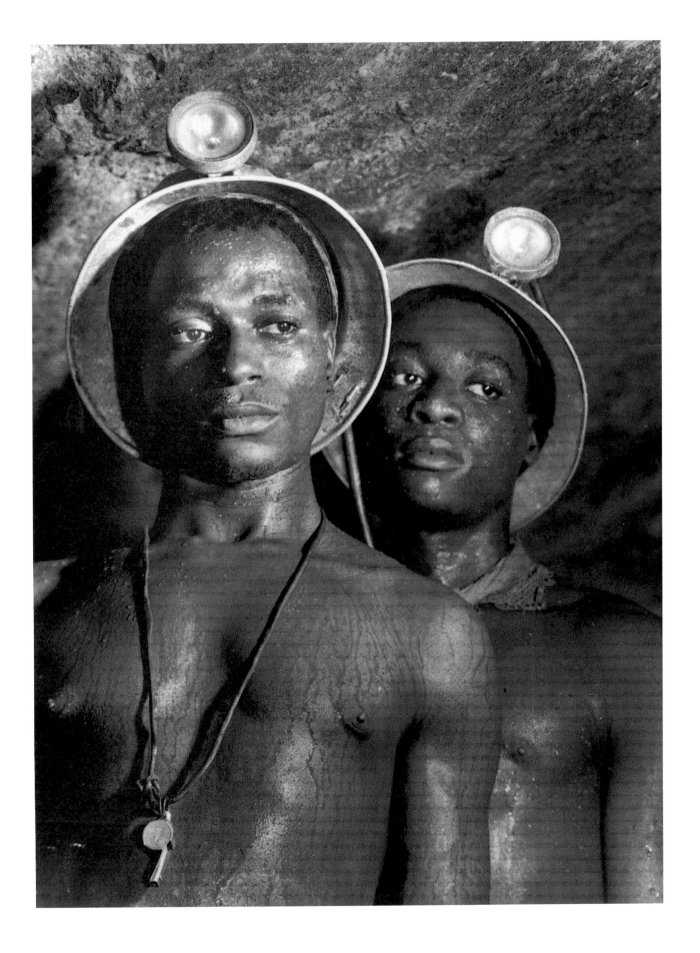

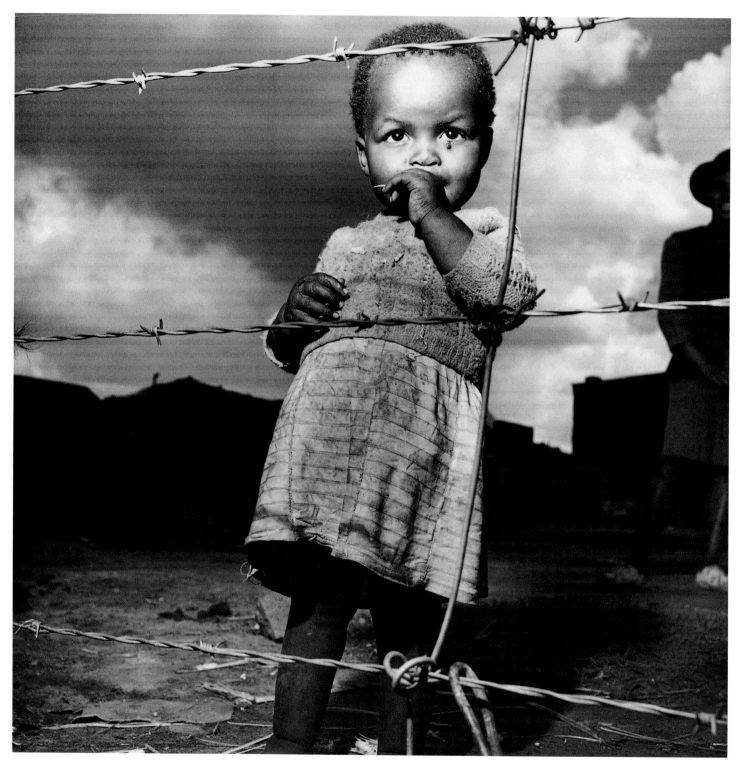

Shantytown Dweller, South Africa, 1950. A three-year-old stands behind
the barbed wire fence that surrounds her home in Johannesburg.

Her next big international story was the war in Korea between the South Korean Nationalists and the North Korean Communists. Other *Life* photographers were already there covering the conflict, but Margaret searched for a unique human-interest angle. She found it in the story of Nim Churl Jin, a South Korean who had become a Communist guerilla.

Guerillas were roaming bands of young soldiers (mostly teenagers) organized by the Communists. They hid in the mountains, living in caves. Under the direction of officers, the guerillas raided villages, and terrorized the peasants. Churl Jin became horrified by the brutal way the Communists treated the peasants. Now he wanted to defect and return home. Margaret photographed his emotional reunion with his mother, who for two years had thought he was dead. As Margaret took pictures, she cried. For her it was one of the most important photographs of her career.

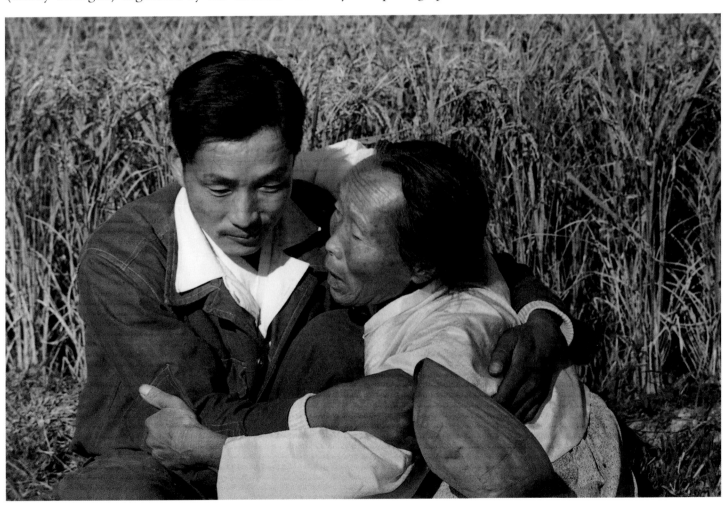

"Is it a dream?" cried Churl Jin's mother. "You cannot be my son. My son is dead." He answered, "Mother, it is Churl Jin." Then she sang a lullaby to him, rocking him in her arms. South Korea, 1952.

Chapter Eight
MAGGIE THE INDESTRUCTIBLE

While she was in Korea, Margaret noticed a dull ache in her left leg, then in her left arm. She found herself staggering whenever she stood up after sitting. Back in the United States Margaret saw many doctors until a neurologist realized what was wrong. He refused to name her disease, thinking it would discourage her. Instead, he prescribed exercises to help her retain whatever strength she had left in her muscles. For therapy, Margaret walked four miles every day, drew with crayons, and crumpled paper into balls. She had always thought of herself as the kind of person who never got sick—"Maggie the Indestructible."

At *Life*, she kept her sickness a secret for fear that her editors would stop giving her assignments. But everyone suspected that something was wrong. Finally, she discovered the name of her illness—Parkinson's disease, an incurable ailment that causes uncontrollable shaking or tremors, makes muscles rigid, and impairs speech. Margaret was only forty-nine, at the height of her career. Instead of feeling sorry for herself, she approached physical therapy with the same intensity and commitment she had always shown for her photography. In 1958 she consulted with a young brain surgeon who thought he could help her with a new kind of operation, which she agreed to try. Afterward Margaret noticed some improvement, but she still needed more physical therapy.

Margaret was now ready to tell the truth about her fight against Parkinson's in the hope of helping others

Alfred Eisenstaedt took this picture of Margaret during her rehabilitation. "At long last I again can load my camera," she wrote as the caption.

suffering from the same disease. She allowed her friend and colleague from *Life*, Alfred Eisenstaedt, to take pictures of her, and they collaborated on a photo-essay about her rehabilitation. Margaret wrote the text, and Eisenstaedt took the pictures, including one of a patient going through an operation like hers. *Life* ran the story on June 22, 1959.

Despite her determination to cure herself, Margaret's disease spread to her right side. She needed a second operation. This time her speech was affected, and she could no longer talk easily. Yet she continued working on her autobiography *Portrait of Myself*, and it was published in 1963. In 1969 she retired from *Life* magazine and put all her strength into staying alive. During these last years she lived alone with her Maine coon cats, Sita and Parvati. "I'm alone but I don't feel lonely," she scribbled on the back of an envelope. In her beloved Connecticut house she was surrounded by mementoes of her travels: brass soup bowls from Korea, copper trays from India, embroidered linen from Russia, and the photomural of the Bohemian Forest.

But she could barely walk or talk. Her ex-sister-in-law Mike (a childhood nickname) White, who had been married to her brother Roger, came to take care of her. Margaret's mind was still alert, and she was putting together notes for another book, anecdotes about the stories behind her pictures. Sitting made her stiff, so she mounted her typewriter on a lectern with casters and pushed it around while she was typing.

A young *Life* reporter, Sean Callahan, helped Margaret select photographs for an exhibition in Boston. There had been few exhibits of her work before. Margaret simply had not had the time or enthusiasm. She had seen herself as a photojournalist rather than as a gallery artist. She and Callahan went through hundreds of prints covering her range of interests from industry to insects, as well as world events. By now, Margaret could only communicate with her eyes. She and Callahan developed a code. One blink for "yes," two blinks for "no."

In the summer of 1971 she fell, cracking three ribs, and had to go to the hospital. Callahan stopped to visit her on his way to Boston to deliver her photographs. Outside he found a praying mantis on a bush and brought it in for Margaret to see. He was going to get a jar from the nurse and leave the insect with Margaret, but she signalled "no" with her eyes. Callahan understood her desire. He let the praying mantis go free. Thirty-six hours later Margaret died. She was sixty-seven.

The following month, *Life* published some of her best-known photographs in tribute. The headline read, "Her cameras took her everywhere, from a boom town to the depths of the earth." And the brief eulogy began, "Her pictures were her life."

The Face of Liberty, New York, 1952. Margaret took this startling face-to-face view of the Statue of Liberty for *Life* from a helicopter. The helicopter, developed during the Korean War, became Margaret's "flying tripod."

Notes

The full credit for each of the sources cited is listed in the bibliography.

Introduction "I Want to Become Famous"

Page 7. Bourke-White, "I want to become famous . . ." is from Bourke-White's diary and quoted in Goldberg, *Margaret Bourke-White: A Biography* (Reading, Massachusetts: Addison-Wesley Publishing Company, Inc., 1987), p.77.

Bourke-White, "tilted like a silver tea tray," is from "Women in Lifeboats," *Life*, February 22, 1943, p. 49.

Bourke-White, "I suppose for all photographers . . ." is from *Portrait of Myself* (New York: Simon and Schuster, 1963), p. 210.

Page 8. Bourke-White, "You are my Sunshine . . ." is from *Portrait of Myself*, p. 211.

Bourke-White, "A feeling of loneliness . . ." is from "Women in Lifeboats," *Life*, February 22, 1943, p. 50.

Bourke-White, "I want to become famous . . ." is from Bourke-White's diary and quoted in Goldberg, p. 77.

Page 10. General Doolittle "You've been torpedoed . . ." is from *Portrait of Myself*, p. 217.

Bourke-White, "I forgot that anything existed . . ." is from *Portrait of Myself*, p. 230.

Chapter 1: The Love of Truth

Page 13. Bourke-White, "My father was very . . ." is from her typed biographical notes, ca. 1930, from the Margaret Bourke-White Collection at the Syracuse University Library, Department of Special Collections.

Joseph White, "Perfect mental and moral home . . ." is from Goldberg, p. 8.

Page 14. Bourke-White, "a born teacher," is from *Portrait of Myself*, p. 105.

Bourke-White, "My name is Margaret . . ." is from Goldberg, p. 14.

Joseph White, "You Can," is from Goldberg, p. 23.

Bourke-White, "Perhaps this unspoken creed . . ." is from *Portrait of Myself*, p. 21.

Bourke-White, "I can hardly describe my joy . . ." is from *Portrait of Myself*, p. 18.

Page 15. Bourke-White, "When a chrysalis . . ." is from *Portrait of Myself*, p. 13.

Bourke-White, "I was very anxious to go to the jungle . . ." is from "Autobiographical Materials" 1928–33, typewritten reports, p. 3, Margaret Bourke-White Papers, Syracuse University Library, Department of Special Collections.

Chapter 2: "I Will Be A Success"

Page 17. Bourke-White, "I think my great love . . ." is from Bourke-White's notes and quoted in Goldberg, p. 24.

Bourke-White, "to be artistic a picture . . ." is from *Portrait of Myself*, p. 30.

Bourke-White, "You somehow absorbed from him . . ." Goldberg, p. 26.

Page 20. Bourke-White, "I should like to be . . ." is from Goldberg, p. 32.

Bourke-White, "Dr. Ruthven is helping me . . ." is from Bourke-White's diary and quoted in Goldberg, p. 32.

Page 21. Mrs. Chapman, "I've lost a son . . ." is from *Portrait of Myself*, p. 27.

Bourke-White, "It was as though everything . . ." is from *Portrait of Myself*, pp. 28–29.

Chapter 3: On a Red-Glove Day

Page 22. Bourke-White, "I chose Cornell . . ." is from *Portrait of Myself*, p. 30.

Bourke-White, "It was the drama . . ." is from *Portrait of Myself*, p. 30.

Page 23. Bourke-White, "What a tantalizing . . ." is from *Portrait of Myself*, p. 31.

Bourke-White, "I was surprised . . ." is from *Portrait of Myself*, p. 30.

Bourke-White, "After the kind . . ." is from *Portrait of Myself*, p. 32.

Bourke-White, "a photographic paradise" is from *Portrait of Myself*, p. 33.

Page 24. Bourke-White, "amazed at the miraculous . . ." is from *Portrait of Myself*, p. 35.

Bourke-White, "What a wonderful . . ." is from *Portrait of Myself*, p. 36.

Mr. Bemis, "Listen, child . . ." is from *Portrait of Myself*, p. 20.

Bourke-White, "I always loved . . ." is from pp. 15–16 of Bourke-White's undated typescript and quoted in Goldberg, p. 74.

Page 32. Bourke-White, "enchanted steel mills" is from *Portrait of Myself*, p. 48.

Bourke-White, "that magic place . . ." is from *Portrait of Myself*, p. 46.

Bourke-White, "a magnificent subject . . ." is from *Portrait of Myself*, p. 49.

Beme, "dancing on the very edge . . ." is from *Portrait of Myself*, p. 50.

Page 33. Newspaper headline, "GIRL'S PHOTOGRAPHS . . ." is from a newspaper dated May 12, 1928, and quoted in Goldberg, p. 91.

Newspaper headline, "DIZZY HEIGHTS HAVE NO TERRORS . . ." is from the *New York Sun* on April 25, 1929, and quoted in Goldberg, p. 99.

Chapter 4: Seeking a Wider World
Page 35. Bourke-White, "This was the very role . . ." is from *Portrait of Myself*, p. 64.

Bourke-White, "I feel as if the world . . ." is from *Portrait of Myself*, p. 64.

Bourke-White, "both enchanted by . . ." is from *Portrait of Myself*, p. 66.

Page 36. Bourke-White, "an eye-stopper . . ." is from *Portrait of Myself*, p. 70.

Parker Lloyd-Smith, "from live hog . . ." is from the first issue of *Fortune*, February 1930, p. 59.

Swift Company, "We use all . . ." is from first issue of *Fortune*, February 1930, p. 182.

Reporter, "If the magazine . . ." is from *U.S. Camera*, May 1940 and quoted in Goldberg, p. 108.

Page 39. Bourke-White, "I tried to get . . ." is from Goldberg, p. 114.

Bourke-White, "I decided that . . ." is from *Portrait of Myself*, p. 78.

Bourke-White, "which projected over," is from *Portrait of Myself*, p. 80.

Graubner, "her second pair of eyes" is from Goldberg, p. 111.
Page 42. Bourke-White, "Nothing attracts me . . ." is from *Portrait of Myself*, p. 90.

Bourke-White, "through the eye . . ." is from "Typed Notes," Margaret Bourke-White Papers, Syracuse University Library, Department of Special Collections.

Bourke-White, "prowled around . . ." is from "Typed Notes."
Page 44. Bourke-White, "You'll laugh when you hear . . ." is from page 7 of an interview on May 8, 1935, on WNEW arranged by *Mademoiselle* magazine.
Page 47. Bourke-White, "seeking a wider world" is from "Typed Notes."

Bourke-White, "great unfriendly shapes" is from *Portrait of Myself*, p. 112.

Bourke-White, "all sorts of . . ." is from *Portrait of Myself*, p. 113.

Minnie Bourke White, "My daughter is going . . ." is from *Portrait of Myself*, p. 106.

Bourke-White, "I suffered a great . . ." is from *Portrait of Myself*, p. 105.

Chapter 5: A New Point of View
Page 49. Bourke-White, "tucking them in . . ." is from *Portrait of Myself*, p. 124.

Caldwell, "I hope something funny . . ." is from *Portrait of Myself*, p. 124.
Page 52. Bourke-White, "Sometimes I would set up . . ." is from *You Have Seen Their Faces*, p. 51.

Bourke-White, "posed candid shot . . ." is from Goldberg, p. 169.

Caldwell, "She was almost like . . ." is from Goldberg, p. 168.

Bourke-White, "This was a new . . ." is from *Portrait of Myself*, p. 127.

Little children, "Look at the . . ." is from *Portrait of Myself*, p. 130.

Robert Van Gelder, "I don't know that . . ." is from *The New York Times Book Review* and quoted in *Margaret Bourke-White* (Ithaca, New York: Cornell University Press, 1972), p. 75.

W. T. Couch, "sentimental slush" is from *Virginia Quarterly Review* and quoted in *Erskine Caldwell* (New York: Alfred A. Knopf, 1994), p. 239.
Page 54. Eisenstaedt, "She was a little . . ." is from the author's interview with Eisenstaedt.

Stackpole, "When she got absorbed . . ." is from the author's interview with Stackpole.
Page 57. "Printing black," is from Goldberg, p. 185.
Page 58. Bourke-White, "Wouldn't it be nice . . ." is from "Writings for Unpublished Book," p. 4, Margaret Bourke-White Papers, Syracuse University Library, Department of Special Collections.
Page 61. Bourke-White, "At the end of twenty . . ." is from *Portrait of Myself*, p. 158.

Bourke-White, "It is my firm belief . . ." is from a script for WMCA broadcast, January 1939, and quoted in Goldberg, p. 213.
Page 63. Bourke-White, "So it is trees . . ." is from *Portrait of Myself*, p. 307.

Chapter 6: Assignment for *Life*
Page 65. Bourke-White, "nervous and tired . . ." is from "Typed Notes."
Page 66. Bourke-White, "The opening air raids . . ." is from Goldberg, p. 241.
Page 67. Editor, "MAKING A NEW . . ." is from Goldberg, p. 246.

Page 68. Bourke-White, "What an insignificant . . . " is from *Portrait of Myself*, p. 183.

Bourke-White, "genial and almost . . ." is from *Portrait of Myself*, p. 184.

Bourke-White, "Days later . . ." is from *Shooting the Russian War*, p. 231 and quoted in Goldberg, p. 247.

Page 70. Bourke-White, "The work has always . . ." is from Goldberg, p. 255.

Bourke-White, "Never have I seen . . ." is from *Portrait of Myself*, p. 244.

Bourke-White, "I knew I was getting . . ." is from *Portrait of Myself*, p. 247.

Page 72. Bourke-White, "We didn't know . . ." is from *Portrait of Myself*, p. 258.

Bourke-White, "But they did . . ." is from *Portrait of Myself*, p. 258.

Page 74. Bourke-White, "I had a deep . . ." is from *Fatherland*, p. 77 and quoted in Goldberg, p. 291.

Bourke-White, "I have to work with a veil . . ." is from *Portrait of Myself*, p. 259.

Chapter 7: Recording the Horror

Page 77. Bourke-White, "Oh, I didn't come . . ." is from *Portrait of Myself*, p. 273.

Bourke-White, "I was filled . . ." is from *Portrait of Myself*, p. 275.

Page 80. Gandhi, "There's the Torturer . . ." is from *Portrait of Myself*, p. 278.

Bourke-White, "I did my job . . ." is from *Portrait of Myself*, p. 283.

Bourke-White, "Writing a book . . ." is from *Portrait of Myself*, p. 300.

Bourke-White, "No one else . . ." is from *Portrait of Myself*, p. 284.

Bourke-White, "There were heartbreaking . . ." is from *Portrait of Myself*, p. 287.

Page 81. Bourke-White, "Nothing in all my life . . ." is from *Portrait of Myself*, p. 299.

Page 82. "On this assignment . . ." is from p. 27 "Calendar," 1955, Margaret Bourke-White Papers, Syracuse University Library, Department of Special Collections.

Bourke-White, "What are you going to do . . ." is from *Portrait of Myself*, p. 322.

Bourke-White, "What are the ethics . . ." is from *Portrait of Myself*, p. 322.

Bourke-White, "I hate gold . . ." is from Bourke-White's biographical materials from 1944–53 in the Margaret Bourke-White Collection, Syracuse University Library, Department of Special Collections.

Bourke-White, "Nothing has made me . . ." is from *Portrait of Myself*, p. 321.

Chapter 8: Maggie the Indestructible

Page 87. Bourke-White, "Maggie the Indestructible" is from *Portrait of Myself*, p. 359.

Page 89. Editor, "Her pictures were her life" is from *Life*, September 10, 1971, page 34.

Bibliography

*Books suitable for young readers

Books about Margaret Bourke-White

ARNOLD, EDWIN T., Ed. *Conversations with Erskine Caldwell.* Jackson and London: University Press of Mississippi, 1988.

————. *Erskine Caldwell Reconsidered.* Jackson and London: University Press of Mississippi, 1990.

*AYER, ELEANOR H. *Photographing the World: Margaret Bourke-White.* New York: Dillon Press, 1992.

BROWN, THEODORE M. *Margaret Bourke-White, Photojournalist.* Ithaca: Andrew Dickson White Museum of Art, Cornell University, 1972.

*CALLAHAN, SEAN, Ed. *The Photographs of Margaret Bourke-White.* Boston: New York Graphic Society, 1972.

*————. *Margaret Bourke-White.* Boston and New York: Little, Brown and Company, 1998.

*DUNHAM, MONTREW. *Margaret Bourke-White: Young Photographer.* New York: Aladdin Paperbacks, 1977.

GOLDBERG, VICKI. *Margaret Bourke-White: A Biography.* Reading, Massachusetts: Addison-Wesley Publishing Company, Inc., 1987.

*————. *Bourke-White.* New York: International Center of Photography, 1988.

*KELLER, EMILY. *Margaret Bourke-White: A Photographer's Life.* Minneapolis: Lerner Publications Company, 1996.

*KIRKLAND, WINIFRED and FRANCES. *Girls Who Became Artists.* New York and London: Harper & Brothers Publishers, 1934.

KLEVAR, HARVEY L. *Erskine Caldwell: A Biography.* Knoxville: The University of Tennessee Press, 1993.

MILLER, DAN B. *Erskine Caldwell: The Journey from Tobacco Road.* New York: Alfred A. Knopf, 1995.

*SIEGEL, BEATRICE. *An Eye on the World.* New York: Frederick Warne, 1980.

*SILVERMAN, JONATHAN. *For the World to See: The Life of Margaret Bourke-White.* New York: Viking Press, 1983.

STOMBERG, JOHN R., Ed. *Power and Paper: Margaret Bourke-White, Modernity, and the Documentary Mode.* Boston University Gallery. Seattle and London: University of Washington Press, 1998.

*WELCH, CATHERINE A. *Margaret Bourke-White: Racing With a Dream.* Minneapolis: Carolrhoda Books, Inc., 1998.

*————. *Margaret Bourke-White.* Minneapolis: Carolrhoda Books, Inc., 1997.

*WOLF, SYLVIA. *Focus: Five Women Photographers.* Morton Grove, Illinois: Albert Whitman & Company, 1995.

Books by Margaret Bourke-White

*BOURKE-WHITE, MARGARET. *Eyes on Russia.* New York: Simon and Schuster, 1931.

*———— (with ERSKINE CALDWELL). *You Have Seen Their Faces.* Athens and London: The University of Georgia Press, 1995.

*———— (with ERSKINE CALDWELL). *North of the Danube.* New York: The Viking Press, 1939.

*———— (with ERSKINE CALDWELL). *Say, Is This the U.S.A.?* New York: Duell, Sloan and Pearce, 1941.

*————. *Shooting the Russian War.* New York: Simon and Schuster, 1942.

*————. *"Purple Heart Valley: A Combat Chronicle of the War in Italy."* New York: Simon and Schuster, 1944.

*————. *Dear Fatherland, Rest Quietly.* New York: Simon and Schuster, 1946.

*————. *Halfway to Freedom.* New York: Simon and Schuster, 1949.

*————. *Portrait of Myself.* New York: Simon and Schuster, 1963.

Books About Photography

GOLDBERG, VICKI. *The Power of Photography: How Photographs Changed Our Lives.* New York: Abbeville Press, 1991.

GRAVES, CARSON. *The Elements of Black-and-White Printing.* Boston and London: Focal Press, 1993.

HILL, PAUL and COOPER, THOMAS, EDS. *Dialogue with Photography.* Manchester: Cornerhouse Publications, 1992.

★IRMAS, DEBORAH and SOBIESZEK, ROBERT A. *the camera i. Photographic Self-Portraits from the Audrey and Sydney Irmas Collection.* Los Angeles County Museum of Art and Harry N. Abrams, Inc., 1994.

MORRIS, JOHN G. *Get the Picture. A Personal History of Photojournalism.* New York: Random House, 1998.

NEWHALL, BEAUMONT. *Latent Image.* Garden City, New York: Doubleday & Company, Inc., 1967.

ROSENBLUM, NAOMI. *A History of Women Photographers.* Paris, London, New York: Abbeville Press, 1994.

★STACKPOLE, PETER. *Life in Hollywood, 1936–1952.* Livingston, Montana: Clark City Press, 1992.

★*The Camera.* New York: Time Life Books, 1970.

TRACHTENBERG, ALAN. *Reading American Photographs. Images as History: Mathew Brady to Walker Evans.* New York: Hill and Wang, 1989.

Books About History

AMBROSE, STEPHEN E. *Americans At War.* Jackson: University Press of Mississippi, 1997.

BLACK, KATHRYN. *In the Shadow of Polio.* Reading, Massachusetts: Addison-Wesley Publishing Company, 1996.

DE JONGE, ALEX. *Stalin and the Shaping of the Soviet Union.* New York: William Morrow, 1986.

GOODWIN, DORIS KEARNS. *No Ordinary Time. Franklin and Eleanor Roosevelt: The Home Front in World War II.* New York: Simon and Schuster, 1994.

RIASANOVSKY, NICHOLAS V. *A History of Russia.* New York and Oxford: Oxford University Press, 1984.

Videos

"Person to Person," CBS, September 2, 1955, 10:30 P.M. Edward R. Murrow, host, interviews Margaret Bourke-White at her home in Connecticut.

Other Sources

Margaret Bourke-White Papers and Memorabilia, Syracuse University Library, Department of Special Collections, Syracuse University, Syracuse, New York.

Typed speech by Doris O'Neil, a member of the Picture Collection staff at *Life*, delivered at Wheaton College, Norton, Massachusetts, September 23, 1981.

Interviews

1. Callahan, Sean, October 29, 1994. As a young reporter for *Life*, Callahan collaborated with Bourke-White on *The Photographs of Margaret Bourke-White.*
2. Eisenstaedt, Alfred (Eisie), March, 1995. Like Bourke-White, Eisenstaedt was one of the first four photographers to be hired by *Life.*
3. Graves, Ralph, May 24, 1995. As a young reporter, Graves covered many stories with Bourke-White. He later became an editor at *Life.*
4. O'Neil, Doris, March, 1995. O'Neil was a director of Vintage Prints at *Time* as well as a picture editor who worked with Bourke-White.
5. Stackpole, Peter, May 19, 1995. Like Bourke-White, Stackpole was one of the first four photographers hired by *Life.*
6. White, Mrs. Mike, February 24, 1995. White was married to Bourke-White's brother, Roger. She and Bourke-White were close friends.
7. White, Jonathan (Toby), March 7, 1995. White is Bourke-White's nephew.

Index